DESIGNER'S GUIDE TO
color

Introductory Essay by James Stockton

Chronicle Books San Francisco

First published in the United States 1984 by
Chronicle Books
One Hallidie Plaza
San Francisco, CA 94102

Printed in Japan

Haishoku Jiten by Ikuyoshi Shibukawa
and Yumi Takahashi
Copyright © 1983 by Kawade Shobo
Shinsha Publishers

Library of Congress Cataloging in Publication Data

Stockton, James.
 Designer's guide to color.

 1. Color.
 2. Color—Psychological aspects.
 3. Color in art.
I. Title.
ND1488.S76 1984
701'.8
84-3203
ISBN: 0-87701-331-4

10 9 8 7 6 5

Contents

Introduction

This compact book is meant to serve primarily as a professional tool for anyone associated with design or the design process. Because of the inclusion of screen values of the four process colors, this book will make perhaps its greatest contribution to those who realize their design through some printed process—graphic designers, certainly; also environmental designers, advertising and package designers and probably some members of architectural firms who become involved in printed media. In a much broader sense, the book has real value to anyone who needs to confirm color ideas or to find color combinations, suggestions and examples presented in a straightforward, pure and neutral way.

Besides the interior designers and fashion designers who also will find this a useful guide to have in an office arsenal are those whose color use is in theater design and costuming. People who design or promote recreational activities will consult the color combinations to heighten enjoyment, excitement and ready identification of team uniforms, jockeys' silks, balloons used for sport, the enormous and highly original arrays of spinnakers and flags used in sailing and yachting and the flags and equipment used for winter sports.

Students and teachers of painting and design will find the presentations of color in this book a place to begin or conclude discussions of color combinations and of their effects on each other, as well as their ultimate effect on the viewer.

How To Use This Book

The book is organized this way: up to page 121, two-color combinations are presented. Each page has one color as the theme or base color, with a variety of contrasting colors placed against it. The page's theme color is repeated as a tab at the edge of the page to facilitate finding it (and all the theme colors are displayed in the array of numbered arcs beginning this book.)

Brilliant three-color combinations are presented on pages 122–123, and some strong colors are combined with white stripes on page 125. Then the three-color combinations continue from page 126 to page 135 with rich additions of grayed colors and, finally, the inclusion of powerful, deep-valued, strong-hued stripes. Use of the color masks built into the book jacket allows any combination to be viewed independently.

Note that the colors presented in this book, which are produced by combining tint values—that is, screen values—of the four basic printing process colors, are accompanied by the numbers designating these values. Throughout the world, most printed color reproduction is the result of optical separation of such art as a painting or illustration (reflective copy) or a photo transparency (projected copy) into four pure and basic ink colors—yellow, cyan, magenta and black—which are then printed precisely on top of each other to yield the full-color effect of the original object. To achieve strong areas of flat color similar to the color samples in this book, percentages of the same four basic process colors can be printed in almost endless combinations. The abbreviated designations for the four colors that are given with the percentages are for the most part uniform internationally—Y stands for yellow, M for magenta, C for cyan and BL or K for black.

In the pages of this book, below each contrast color (and above each new theme color) is a small notation on what combination of tints of the four basic colors was used to achieve that color.

It is very important to remember that while the method for reproducing the four process colors is basically the same for lithography and letterpress printing worldwide, the chemical composition and properties of inks varies somewhat from country to country and even from printer to printer. The inks used to achieve the colors in this book are Japanese: the resulting four colors by themselves appear different from their American counterparts, as do Dutch inks, Italian inks and others. Magenta is probably the ink color with greatest variance. It is easy to compensate for these discrepancies, but a designer with inks other than those used in manufacturing this book who strives to match exactly one of the colors represented here should take the discrepancies into account. Variances in ink density or how much ink is allowed to lay on the printed surface also drastically affects the quality of the color being reproduced. All this reenforces the need for any designer to be at press-side for a final check when a job is being printed.

Another factor that substantially affects the quality and appearance of printed color is the paper or surface of the paper on which the ink is printed. Graphic designers who work with a lot of printed color struggle with these variables routinely; they are surmountable if they are remembered at the planning stage. Among other things, design *is* planning.

Some Attributes of Color Perception

Clear though an array of colors may appear on a page to some, a great number of factors affect perception of them, including physiological capacity and the questionable powers of emotional associations and stylistic preferences.

Color produced by elements that project light—such as colored lights, television, slides and movies—differs greatly in quality, composition and effect from color that is reflected from the page, as in this book.

Elemental in any discussion of color are the distinctions and contributions of the terms hue, value and intensity. Quite simply, *hue* describes the position of a color on a classic color wheel and is used to name the color—*yellow, violet or green,* for example. *Value* describes the lightness or darkness of the color—its position on a scale from white to black. *Intensity* refers to the brightness, saturation and impact of the color.

Opthalmologists maintain that the ability of the eye to distinguish colors diminishes on a regular curve with old age. Some say that they can gauge the age of a person by testing perceptions of hue, value and intensity. (One who anticipates a color project for elderly people might effectively use this book as a device to determine preferences on these three counts.)

In the study of color, much attention is devoted to the effect of colors on the colors next to them. Depending on the relative positions of colors on the color wheel, many when placed next to each other somewhat cancel each other and seem grayed, or they produce the effect of creating an additional color unlike the originating two. These effects are most easily distinguishable if the juxtaposed colors are in relatively small panels or if the colors are viewed from a distance. Some of the conditions producing grayed or additional colors are discernible in the samples in this book (208, 343, 396, 1036 and 1038, to name a few). Grays usually are the product of actually mixing colors that are across the color wheel from each other. And, as in this book, many grays or grayed colors are achieved by adding black to a combination of the other three process colors (see sample 1089). Other grays are created by using fairly equal percentages of yellow, cyan and magenta but no black, with varying results. Look at the quality of the grays in samples 1079 and 1084, then compare the reddish gray on page 85. Throughout the book there are many opportunities as well to see the effects colors have on grays placed next to them; see for instance the same gray be-

side different colors in samples 1079 and 1098 and in 1083 and 1084.

Evoking the optical effect sometimes known as negative afterimage is a good trick, but it's one with real value in confirming colors. The phenomenon can be simply demonstrated by placing a sample of one of the primary colors against a light, neutral gray background. After one stares at the color for a minute or so, if it is quickly pulled away a clear image in the shape of the original color will appear exactly in the place of the color, but it will appear in the complementary hue found directly across the color wheel. For instance, if red is chosen as the demonstrator its negative afterimage will be green.

Another example of the effect of color is its influence on apparent size. Generally, brighter color bars seem larger than darker color bars of the same size; but there are many exceptions to this. Value and position are additional factors that play important roles in perception of size. In use, some of these factors are surprising and unpredictable; see for example the apparent difference in size of the gray panels in samples 734 and 739. In nature, the use of color in camouflage provides dramatic evidence for the effect (or absence of effect) of color on the perceptions of other animals.

The many psychological aspects of color often seem more emotional and personal than scientific, and determining agreement in reactions to colors is sometimes difficult. However, most people do agree that some color combinations imply heat and some cold, and that some connote pleasure and others pain. Painters, and particularly the Impressionists, have relied on these ideas to produce dimension, form and mood. Red can be, among other things, either a welcome or a warning, conveying either warmth or danger. The "voice" of a color depends largely on the colors that are placed next to it—the essence of this book.

Roche Laboratory has developed an elaborate "spectrum of human emotions" color wheel. It is beautifully presented in *Living by Design: Words and Pictures,* by Pentagram (published by Lund Humphries, London, and the Whitney Library of Design, New York, 1978). Unchallenged, it assigns "reserved" to blue, "active" to red, and so on. Regardless of the absolute accuracy of these designations, that moods can be evoked and manipulated by our historical and cultural associations with color is certain. Some combinations immediately evoke the 1950s, the military, the Federal period, and a feeling of the baroque. Generally, color can produce an appropriate setting, tone or mood for the

subject at hand. This sort of color use is nowhere more powerful than in the theater, opera and ballet. On stage, color is seldom static; and constantly layered and shifting combinations of color that are carefully modulated and controlled can benefit an entire production. As in the print media, the trained and deliberate placement on stage of small areas of color contributes to the emotional impact of the larger piece.

Taste and style—elusive, priceless and seemingly innate—are frequently revealed or defined by color. Some color combinations historically connote and confirm these qualities; some reveal and betray the perpetrator. A great deal of one's sensitivity to such issues is conditioned and acquired, but some color applications are so brilliant, original and powerful that people who exhibit color awareness and skills seem to be driven by special talents. Trendiness in the use of color, on the other hand, is contrived, deliberate and designed to shine brightly for a short time. Color trends are very perceptible, and they attach themselves indelibly to eras, products and fashions. As you go through the book, some color combinations will seem strongly nostalgic and others will seem just fine for the current scene.

Other Resources
An investigation of the subject of color will probably send you off to the library and bookstores and, perhaps best of all, to review some favorite resource materials from your own bookshelves. Many helpful books are available. Three I have found particularly useful are:

□ Johannes Itten's *The Art of Color* (New York: Van Nostrand Reinhold, 1973). This is "correct," thorough, technical and theoretical, yet its richness of approach makes it also a joy to read. Itten's book is an elegant treatment of a technical subject.

□ *Color*, edited by Donald Pavey (Los Angeles: The Knapp Press, 1980). This is a fine recent book.

□ Harald Kueppers' *The Basic Law of Color Theory* (Woodbury, N.Y.: Barron's, 1982). While this is very technical, it is also of great interest.

As for this book, use it as a reference tool, a guide, a resource and a problem solver. It will reinforce your color knowledge and clarify your color needs. It may even give you some ideas.

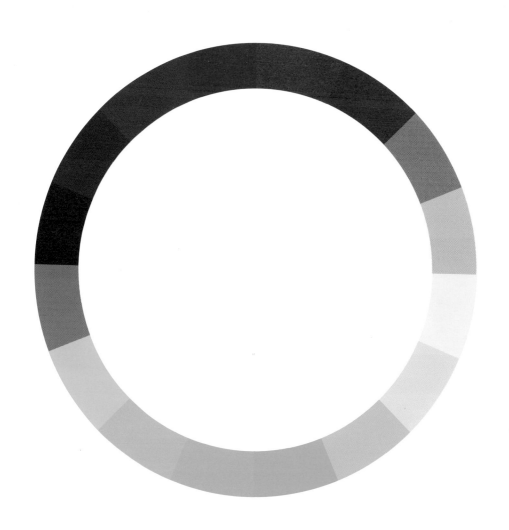

9

Presented here are the ninety basic colors shown in this book. Ten to twenty alternate

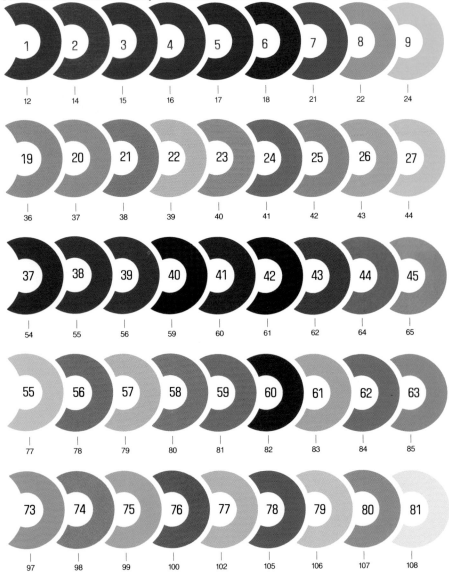

colors are displayed with each color. The numbers below each color are page numbers.

10	11	12	13	14	15	16	17	18
25	26	27	28	29	30	32	33	35

28	29	30	31	32	33	34	35	36
45	46	47	48	49	50	51	52	53

46	47	48	49	50	51	52	53	54
66	68	69	70	71	72	73	74	75

64	65	66	67	68	69	70	71	72
86	87	88	89	91	92	94	95	96

82	83	84	85	86	87	88	89	90
109	110	112	113	115	116	117	118	120

11

1 Y100 M100

 C100 BL30

2

 Y100 M40

3

 Y60 C100

4

 Y80 M20 C80 BL50

5

 Y80 M90 C50 BL20

6

 M90 C100

7

 Y100 C100

8

 Y40 M40 C40

9

 Y100 M70

10

 Y70 M70 C100

11

Y40 C100

16

Y80 M60 C50

12

M100 C80

17

Y10 C50 BL50

13

M100 C40

18

Y100 BL30

14

Y100 M60 C70

19

M50 C100

15

Y100 M80 C80 BL10

20

Y40 C90 BL90

13

21 Y50 M100
 Y60 C100

22 Y30 M20 C20

23 M100 C40

24 Y20 M30 C80

25 Y80 M100 BL80

26 Y60 M20 C10

27 Y50 M50 C70

28 M70 C100

29 Y100 M60

30 Y100 M40 C60

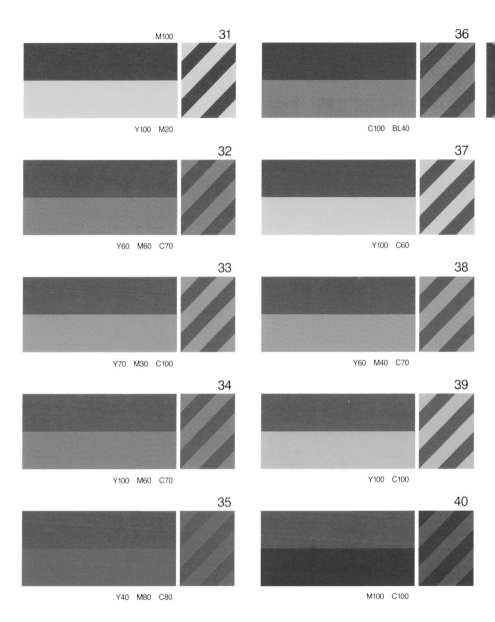

M100 **31**

Y100 M20

36

C100 BL40

32

Y60 M60 C70

37

Y100 C60

33

Y70 M30 C100

38

Y60 M40 C70

34

Y100 M60 C70

39

Y100 C100

35

Y40 M80 C80

40

M100 C100

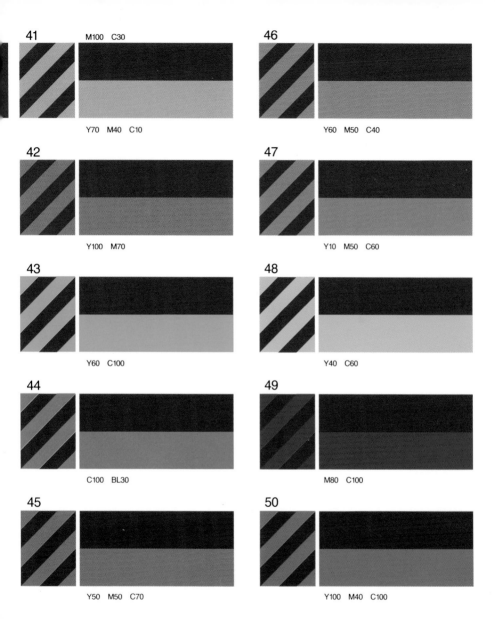

41 M100 C30

Y70 M40 C10

42

Y100 M70

43

Y60 C100

44

C100 BL30

45

Y50 M50 C70

46

Y60 M50 C40

47

Y10 M50 C60

48

Y40 C60

49

M80 C100

50

Y100 M40 C100

M100 C70 **51**

Y30 M60

56

Y100 C100

52

Y100 M90

57

Y50 M40 C20 BL10

53

M100

58

Y100 C40

54

Y90 M40 C30

59

Y50 M10 C100

55

Y30 M40 C70

60

Y60 M70 C40

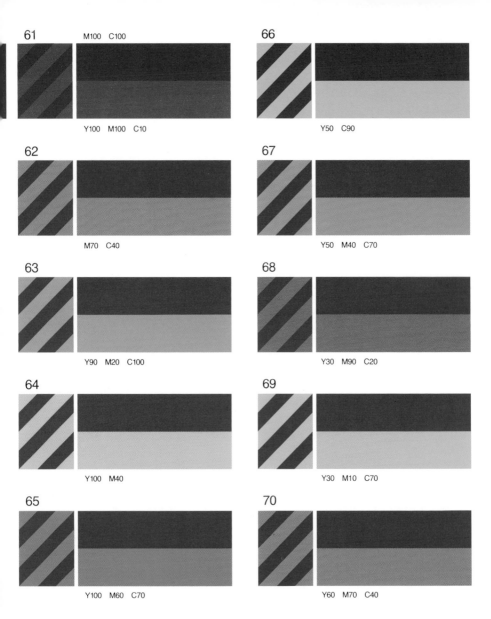

61 M100 C100
Y100 M100 C10

62 M70 C40

63 Y90 M20 C100

64 Y100 M40

65 Y100 M60 C70

66 Y50 C90

67 Y50 M40 C70

68 Y30 M90 C20

69 Y30 M10 C70

70 Y60 M70 C40

M100 C100 **71**

Y100 M90

 76

Y100 M20

 72

Y90 M50 C20

 77

Y30 M30 C30 BL30

 73

Y40 M30 C30

 78

Y80 M100 C50 BL10

 74

Y50 M10 C60

 79

Y80 M50 C40

 75

Y100 M20 C40

 80

Y80 C100 BL90

Color: The Extent of the Effect

To see or feel blue may be more than metaphorically color related. With some simply viewing the color red can raise one's blood pressure; correspondingly, blue can reduce it. (From most to least stimulating, the ranking of other colors tested is orange, yellow, and green.) Shades of soft pink can quiet the agitated sufficiently that walls have been painted this way in some jail holding quarters. Associations from leisurely periods spent gazing at water or skies, for example, might be evoked by gazing at any medium blue. Discriminating which responses to color are learned and which are innate is no more possible than determining whether new ideas are the products of unprecedented insight or of subconscious reasoning.

Kandinsky asserted that a circle of yellow seems to spread in all directions from its center and, conversely, that a circle of blue conveys movement that is concentrically inward, in the pattern of a snail's shell. Nonetheleless, numerous studies of the color preferences of various populations, although they have stimulated many theories, have turned up no absolutes about how colors affect people directly. Kandinsky's further theory that yellow is related to triangular shapes, blue to circles and red to squares was perhaps useful for the artist, but was not, broadly speaking, true.

81
M80 C100

Y80 M40 C30 BL10

82

Y60 M60 C40

83

Y10 C100

84

Y50 M40 C30

85

Y50 M100 C40

86

Y30 M100

87

Y90 M70

88

Y30 C20 BL40

89

Y60 C100

90

M30 C30 BL30

21

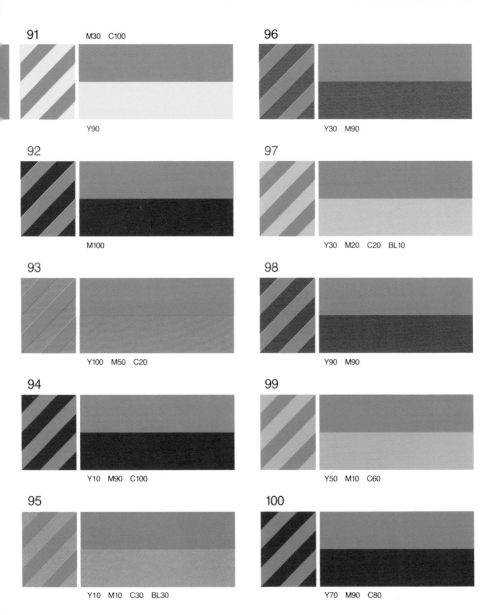

91 M30 C100

Y90

96

Y30 M90

92

M100

97

Y30 M20 C20 BL10

93

Y100 M50 C20

98

Y90 M90

94

Y10 M90 C100

99

Y50 M10 C60

95

Y10 M10 C30 BL30

100

Y70 M90 C80

101

Y50 C90

106

Y90 M30

102

Y10 M100 C20

107

M50 C50

103

Y100 C60

108

Y80 M50 C40

104

Y50 M40 C70 BL50

109

Y70 M70 C20

105

M100 C70

110

Y90 M80 C80 BL10

23

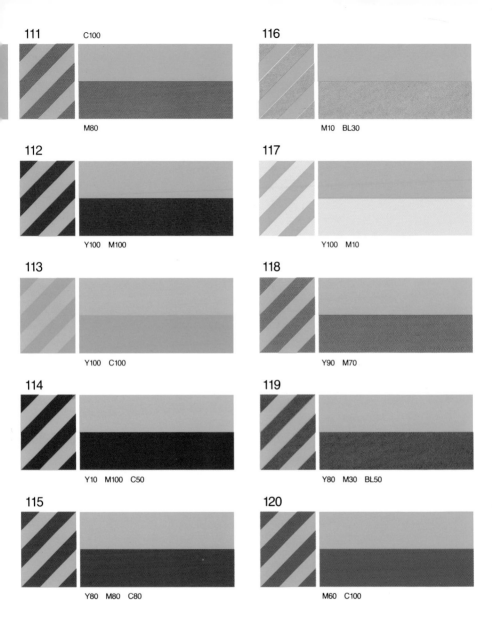

111 C100

M80

112

Y100 M100

113

Y100 C100

114

Y10 M100 C50

115

Y80 M80 C80

116

M10 BL30

117

Y100 M10

118

Y90 M70

119

Y80 M30 BL50

120

M60 C100

Y30 C100 121

Y10 M100 122

Y100 M40 123

Y30 M20 C20 BL30 124

Y90 M100 C50 125

Y90 M30 C70 BL50

126

Y40 C30 BL50 127

Y80 M100 C10 128

Y50 M40 C30 129

M30 C60 130

Y90 M70 C80 BL10

25

131 Y60 C100
Y30 M20 C40

136
Y50 M70

132
M70 C30

137
Y100 M50 C30

133
Y100 M90

138
Y80 M60 C50

134
Y30 M100

139
C100 BL50

135
Y80 M100 C70

140
Y90 M90 C90

26

Y100 C100 **141**

M90 C60

146

Y80 M10

142

M90

147

Y30 M30 C60

143

Y100 M70

148

Y90 M100

144

Y50 M90 C70 BL10

149

Y60 M40 C40

145

Y60 M60 C30

150

M90 C100

151 Y100 C80

M50 C70

156

Y80 M30 C20

152

M100 C80

157

Y80 M100 C50

153

Y30 M100

158

Y100 M100 C10

154

Y100 M80 C30

159

Y80 M80

155

Y10 C100

160

Y90 M70 C80

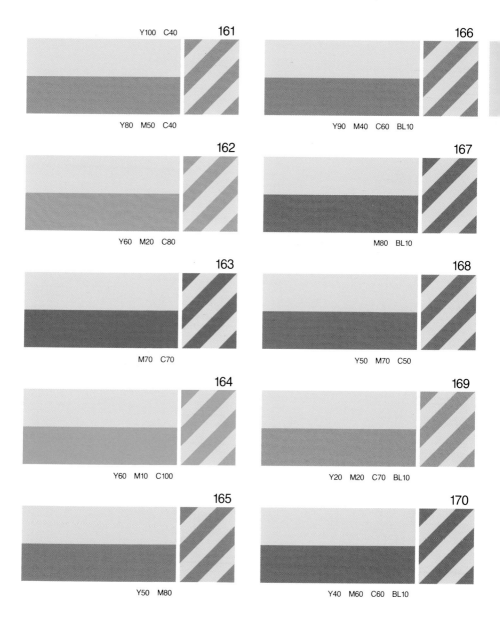

Y100 C40 **161**
Y80 M50 C40

166
Y90 M40 C60 BL10

162
Y60 M20 C80

167
M80 BL10

163
M70 C70

168
Y50 M70 C50

164
Y60 M10 C100

169
Y20 M20 C70 BL10

165
Y50 M80

170
Y40 M60 C60 BL10

29

171 Y100

Y10 M50 C70

172

Y20 M20 C50 BL10

173

Y50 C70

174

Y70 C100

175

Y100 M100

176

M100 C10

177

Y10 M40 C100

178

M10 C80

179

Y90 M40 C60 BL10

180

Y90 M50 C60

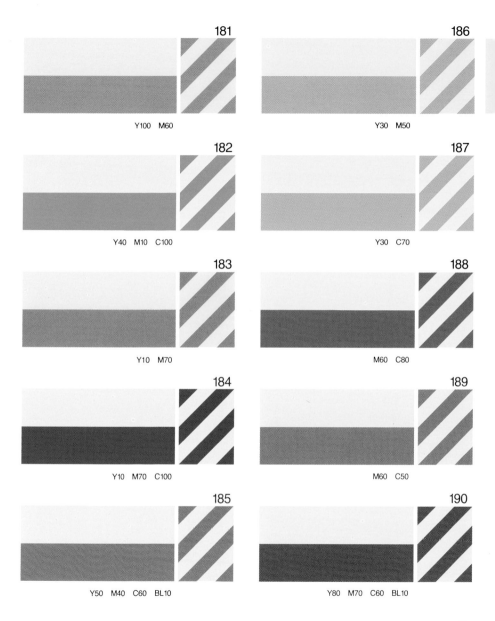

181
Y100 M60

186
Y30 M50

182
Y40 M10 C100

187
Y30 C70

183
Y10 M70

188
M60 C80

184
Y10 M70 C100

189
M60 C50

185
Y50 M40 C60 BL10

190
Y80 M70 C60 BL10

31

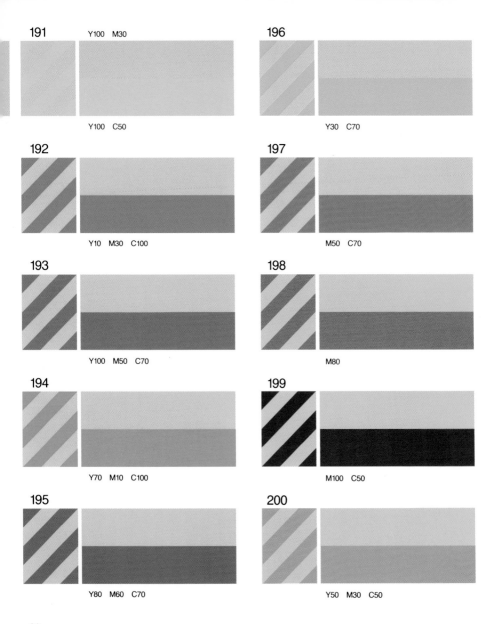

191
Y100 M30
Y100 C50

196
Y30 C70

192
Y10 M30 C100

197
M50 C70

193
Y100 M50 C70

198
M80

194
Y70 M10 C100

199
M100 C50

195
Y80 M60 C70

200
Y50 M30 C50

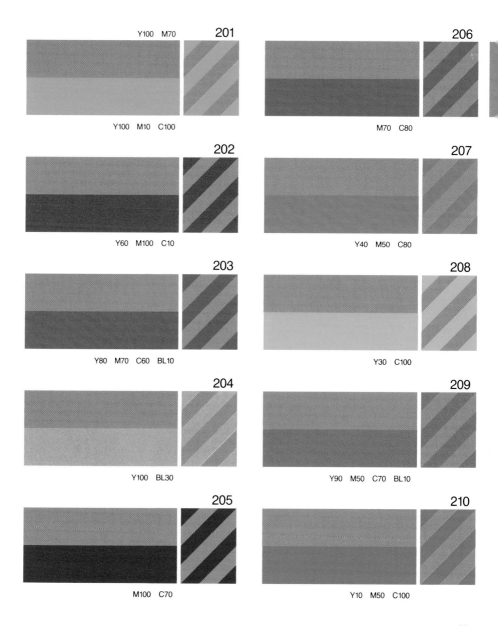

Y100 M70 **201**

Y100 M10 C100

206

M70 C80

Y60 M100 C10 **202**

207

Y40 M50 C80

203

Y80 M70 C60 BL10

208

Y30 C100

204

Y100 BL30

209

Y90 M50 C70 BL10

205

M100 C70

210

Y10 M50 C100

Variations on Red

The role of color in cultural history is intimately tied to the scarcity of dyes and their resulting value. In about 1000 B.C. Phoenician traders marketed a dye in an elegant deep red color close to purple, that was made from murex seashells and was highly regarded for its clarity and permanence. Confucius lamented when it was introduced to China that its costly beauty would cause social disorder. Today, with synthetic dyes abundant, the murex shells are cultivated only in southern Mexico.

Use of expensive colors has enforced social position in many eras, and as significant as being born to the purple in Europe was sporting intensely red clothing in ancient Japan, when a tiny amount of red dye was worth the total assets of two ordinary households. The bulk of the population was forbidden to use the dye. Women could wear clothes of only a faint red color derived by a cheap method of dyeing that produced, actually, a shade of pink; pink, then, signaled meager income and social restrictions.

About 4000 years ago in the Orient people dabbed red clay on their lips to ward off unwanted spirits, and even in recent times some Asian fishermen have worn red loin cloths to ward off sharks; red has been endowed with special charms. In fact, along with black and white red may be one of humankind's three basic colors, as defined by some anthropologists and ethnologists. White and red are associated with life activities; black usually indicates death, misfortune or evil, or simply opposition to white's yielding and acceptance and purity. As clearly in opposition as are black and white to North American eyes are red and white to people in other quarters of the world, and dichotomous red generally assumes the most active and overt role.

Y100 M90 **211**

M100 C100

216

Y100 C100

212

Y60 M50 C50 BL10

217

Y70 BL30

213

Y40 M100 C20

218

M60 C70

214

Y40 M30 C60

219

Y100 M70 C80

215

Y90 M40 C10

220

Y10 M60 C100

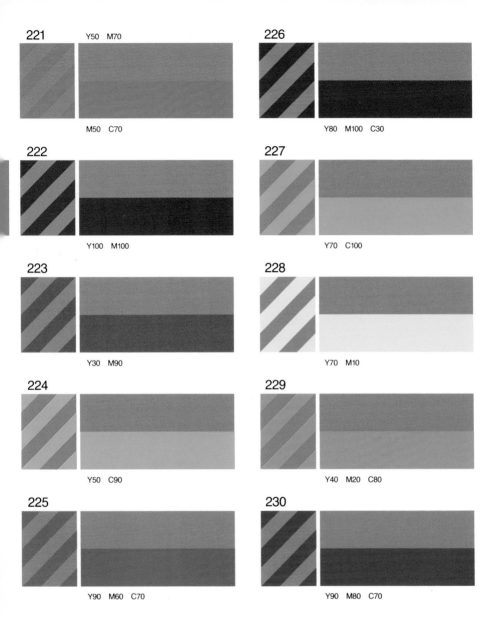

221
Y50 M70
M50 C70

226
Y80 M100 C30

222
Y100 M100

227
Y70 C100

223
Y30 M90

228
Y70 M10

224
Y50 C90

229
Y40 M20 C80

225
Y90 M60 C70

230
Y90 M80 C70

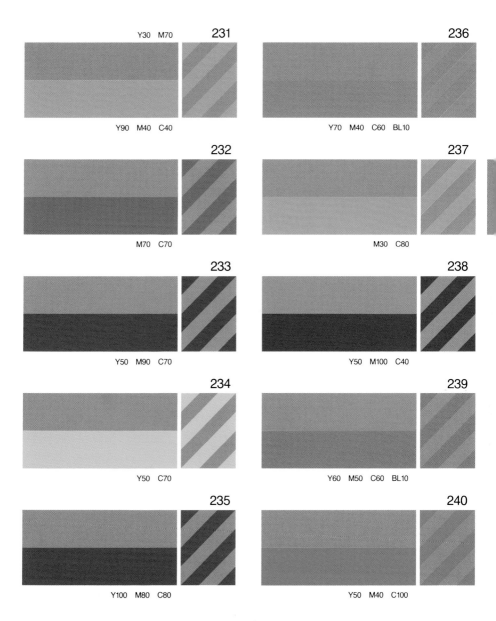

Y30 M70 **231**

Y90 M40 C40

Y70 M40 C60 BL10 **236**

M70 C70 **232**

M30 C80 **237**

Y50 M90 C70 **233**

Y50 M100 C40 **238**

Y50 C70 **234**

Y60 M50 C60 BL10 **239**

Y100 M80 C80 **235**

Y50 M40 C100 **240**

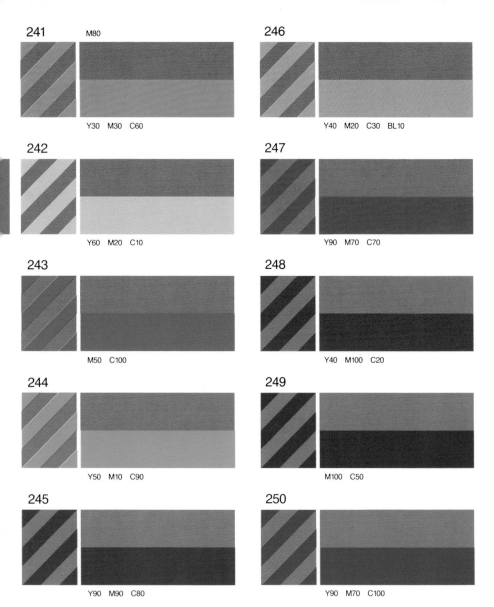

241 M80

Y30 M30 C60

242

Y60 M20 C10

243

M50 C100

244

Y50 M10 C90

245

Y90 M90 C80

246

Y40 M20 C30 BL10

247

Y90 M70 C70

248

Y40 M100 C20

249

M100 C50

250

Y90 M70 C100

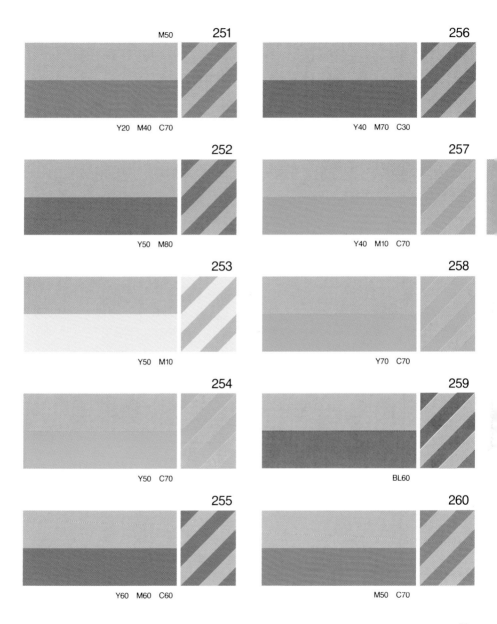

251 M50
Y20 M40 C70

256
Y40 M70 C30

252
Y50 M80

257
Y40 M10 C70

253
Y50 M10

258
Y70 C70

254
Y50 C70

259
BL60

255
Y60 M60 C60

260
M50 C70

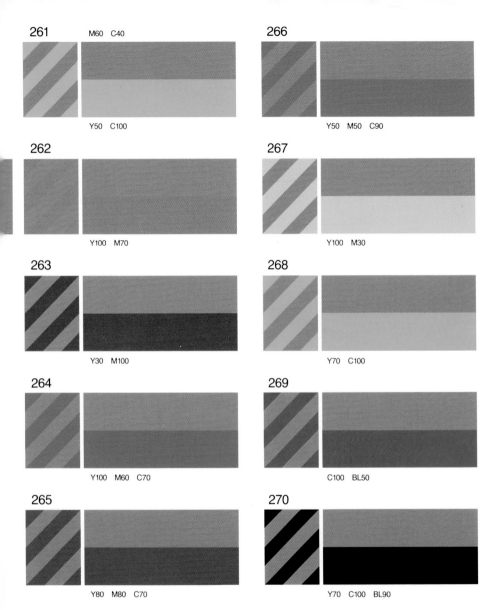

261 M60 C40

Y50 C100

266

Y50 M50 C90

262

Y100 M70

267

Y100 M30

263

Y30 M100

268

Y70 C100

264

Y100 M60 C70

269

C100 BL50

265

Y80 M80 C70

270

Y70 C100 BL90

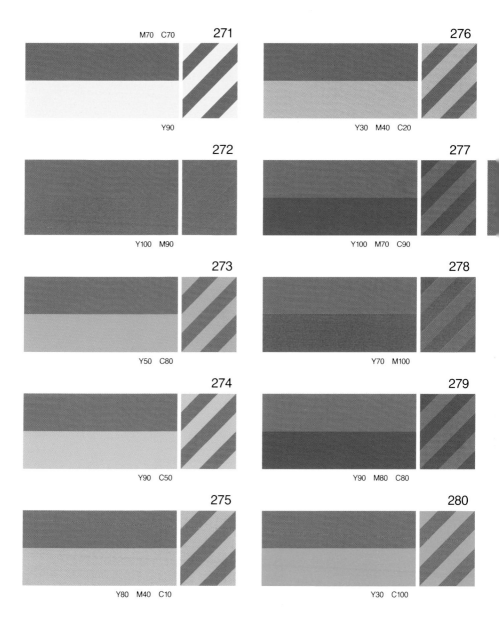

271 M70 C70 Y90

276 Y30 M40 C20

272 Y100 M90

277 Y100 M70 C90

273 Y50 C80

278 Y70 M100

274 Y90 C50

279 Y90 M80 C80

275 Y80 M40 C10

280 Y30 C100

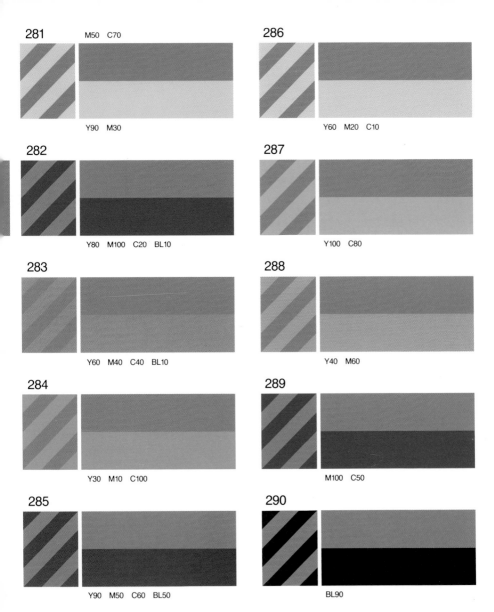

281 M50 C70
Y90 M30

282
Y80 M100 C20 BL10

283
Y60 M40 C40 BL10

284
Y30 M10 C100

285
Y90 M50 C60 BL50

286
Y60 M20 C10

287
Y100 C80

288
Y40 M60

289
M100 C50

290
BL90

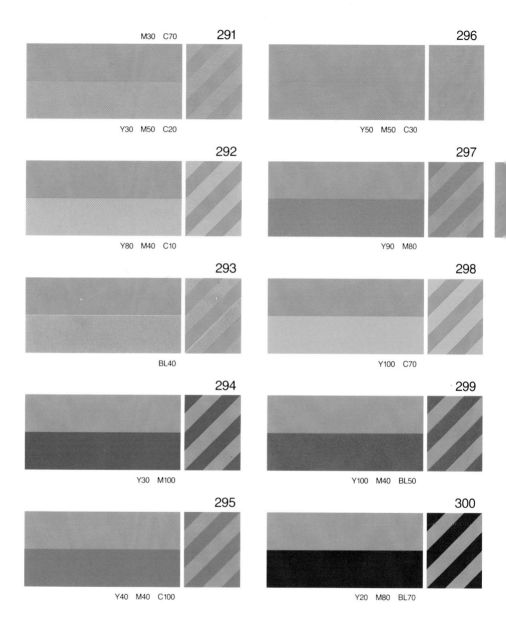

M30 C70 **291**

Y30 M50 C20

292

Y80 M40 C10

293

BL40

294

Y30 M100

295

Y40 M40 C100

296

Y50 M50 C30

297

Y90 M80

298

Y100 C70

299

Y100 M40 BL50

300

Y20 M80 BL70

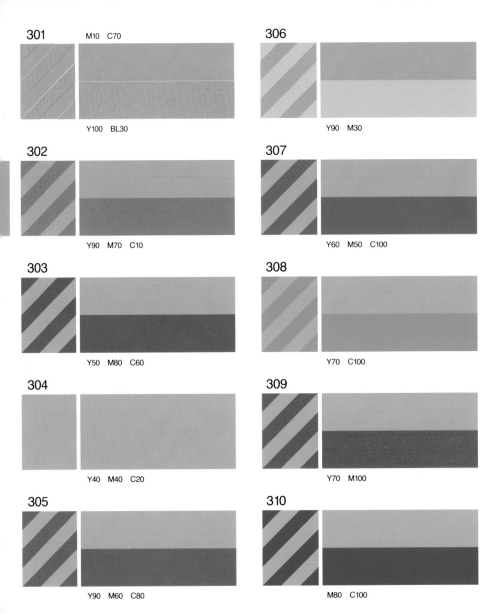

301 M10 C70 / Y100 BL30

306 Y90 M30

302 Y90 M70 C10

307 Y60 M50 C100

303 Y50 M80 C60

308 Y70 C100

304 Y40 M40 C20

309 Y70 M100

305 Y90 M60 C80

310 M80 C100

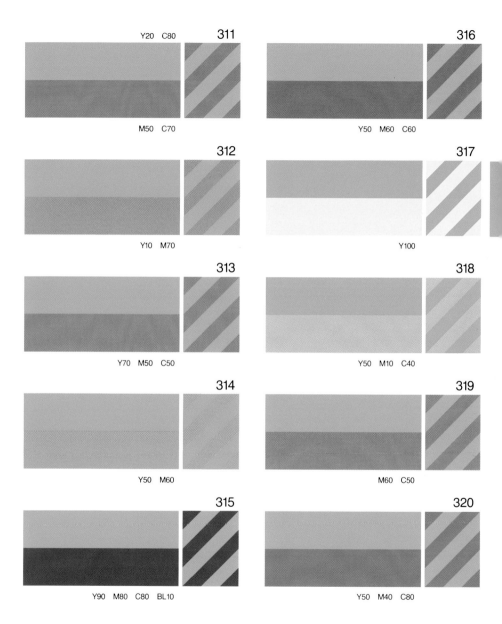

Y20 C80 **311**

M50 C70

316

Y50 M60 C60

Y10 M70 **312**

317

Y100

Y70 M50 C50 **313**

318

Y50 M10 C40

Y50 M60 **314**

319

M60 C50

Y90 M80 C80 BL10 **315**

320

Y50 M40 C80

321 Y30 C70

M50 C80

322

Y20 M70 C20

323

Y40 M40 C70

324

Y50 M40 C40

325

Y60 M100 C70

326

Y50 M20 C20

327

Y30 M50

328

Y10 M80

329

Y100 M70 C90

330

Y80 M50

46

Y50 C70　331

Y30 M30 C30

336

Y80 M30 C20

332

M90

337

M50 C60

333

M100 C40

338

Y70 M100

334

Y70 M70 C30

339

Y20 C100

335

Y50 M100 C100

340

M60 BL50

47

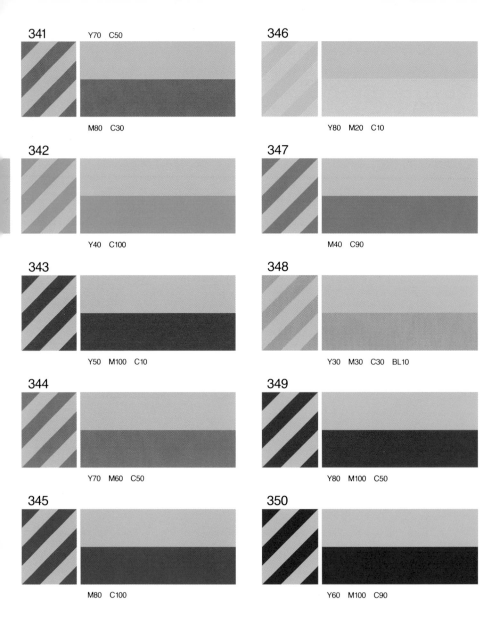

341 Y70 C50
M80 C30

346
Y80 M20 C10

342
Y40 C100

347
M40 C90

343
Y50 M100 C10

348
Y30 M30 C30 BL10

344
Y70 M60 C50

349
Y80 M100 C50

345
M80 C100

350
Y60 M100 C90

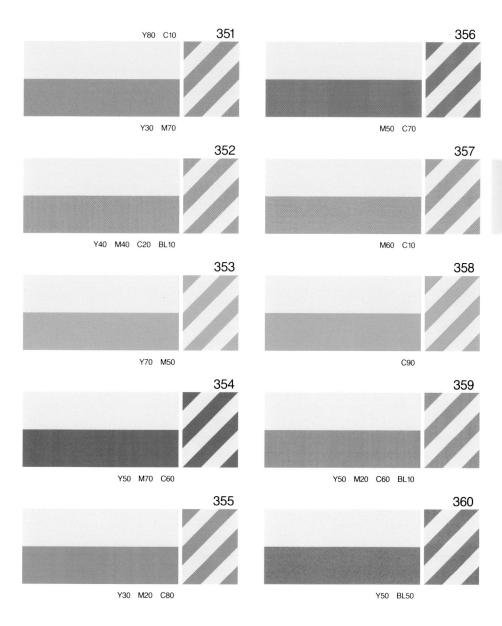

Y80 C10 **351**

Y30 M70

- **356**

M50 C70

352

Y40 M40 C20 BL10

357

M60 C10

353

Y70 M50

358

C90

354

Y50 M70 C60

359

Y50 M20 C60 BL10

355

Y30 M20 C80

360

Y50 BL50

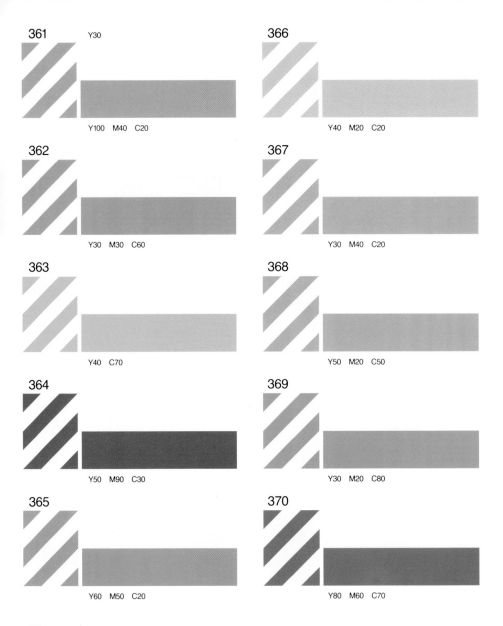

361 Y30

Y100 M40 C20

366

Y40 M20 C20

362

Y30 M30 C60

367

Y30 M40 C20

363

Y40 C70

368

Y50 M20 C50

364

Y50 M90 C30

369

Y30 M20 C80

365

Y60 M50 C20

370

Y80 M60 C70

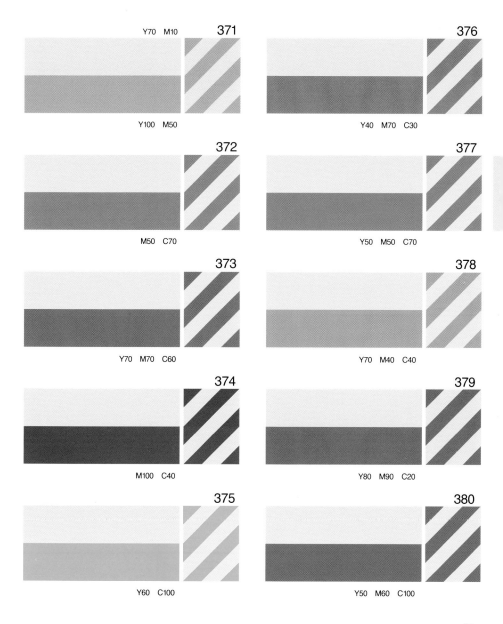

Y70 M10 **371**

Y100 M50

376

Y40 M70 C30

372

M50 C70

377

Y50 M50 C70

373

Y70 M70 C60

378

Y70 M40 C40

374

M100 C40

379

Y80 M90 C20

375

Y60 C100

380

Y50 M60 C100

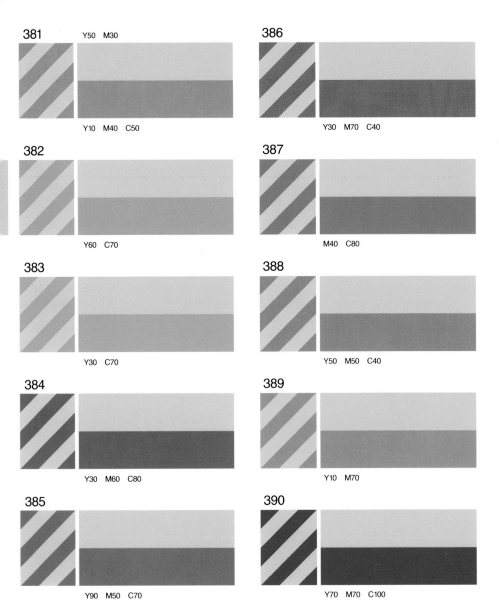

381 Y50 M30
Y10 M40 C50

386 Y30 M70 C40

382 Y60 C70

387 M40 C80

383 Y30 C70

388 Y50 M50 C40

384 Y30 M60 C80

389 Y10 M70

385 Y90 M50 C70

390 Y70 M70 C100

52

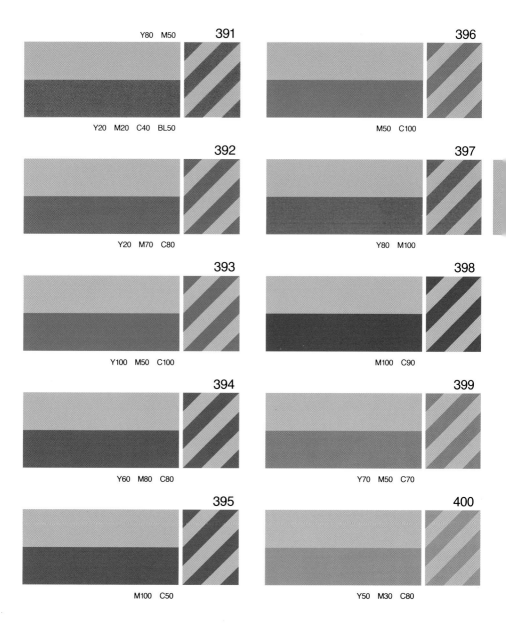

391
Y80　M50

Y20　M20　C40　BL50

396

M50　C100

392
Y20　M70　C80

397

Y80　M100

393

Y100　M50　C100

398

M100　C90

394

Y60　M80　C80

399

Y70　M50　C70

395

M100　C50

400

Y50　M30　C80

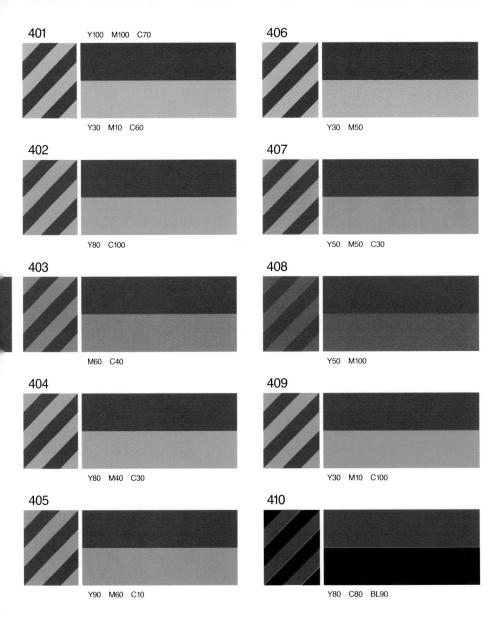

401 Y100 M100 C70
Y30 M10 C60

406
Y30 M50

402
Y80 C100

407
Y50 M50 C30

403
M60 C40

408
Y50 M100

404
Y80 M40 C30

409
Y30 M10 C100

405
Y90 M60 C10

410
Y80 C80 BL90

Y80 M100 C30 411

Y30 M30 C30

412

Y90 M40 C70 BL50

413

Y50 C100

414

Y40 M70 C100

415

Y80 M50 C60

M10 BL40 416

417

M100 BL60

418

M100 C60

419

Y50 M60 C100

420

Y90 M50 C20

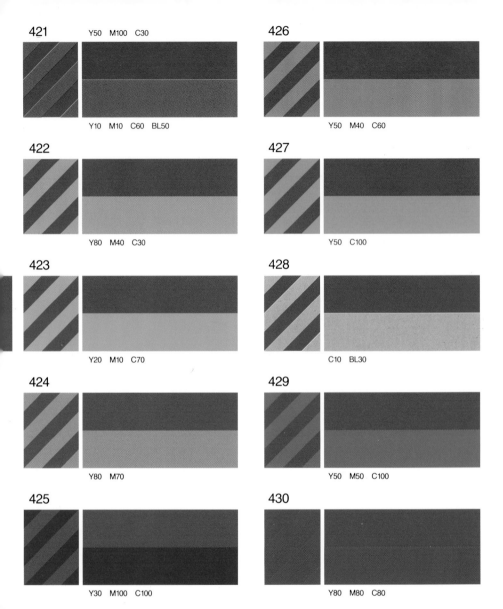

421 Y50 M100 C30

Y10 M10 C60 BL50

422

Y80 M40 C30

423

Y20 M10 C70

424

Y80 M70

425

Y30 M100 C100

426

Y50 M40 C60

427

Y50 C100

428

C10 BL30

429

Y50 M50 C100

430

Y80 M80 C80

Y50 M100 C30 **431**

Y30 M50 C50

436

Y40 M30 C40

432

Y100 C70

437

M70 C100

433

M60 C70

438

Y60 M60 C50

434

Y90 M60 C80

439

Y40 M10 C60

435

Y70 M30 C100

440

Y30 M100 C70

57

Pair Interpretation

The Lüscher color test was developed in Germany as a minutely elaborate means of interpreting one's preference in the ordering of eight color samples. The simplified form of the test uses swatches of eight colors, including gray and black, which the person whose reactions are being gauged is instructed to place in some personally acceptable sequence. They are to choose the order for the colors themselves, not because of associations to the colors. (Ironically, validity is claimed even with color-blind subjects, because degree of brightness of color preferred is said to be an adequate and instinctive response, regardless of hue.) The resulting preferences are analyzed according to well-established conventions developed by Lüscher, with results that are partly predictable and partly surprising. What's predictable are some of the characteristics associated with single colors: blue denotes tranquility and contentment, red indicates excitability and sexuality, and yellow is expansive and shows exhilaration. But green, in nature so pervasively vital, takes the role of defensiveness and obstinacy. More elaborate interpretations are made of combinations of the eight colors in several sets of pairs. What happens when one begins selecting an ordered set of colors is that those picked first seem to need balance, so that each succeeding color chosen influences the order of those that follow; Lüscher may not know exactly what he tests, but if colors participate as deeply in human consciousness as cultural use of them suggests, integrated groupings of a representative set of hues may indeed be telling.

Although Lüscher links accuracy of interpretation for an individual to the relative positions of color pairs, for the sake of interest in pairings per se, here are some condensed interpretations of color samples. (The hues used resemble colors on the array of arcs at the front of this book: the gray is akin to number 71; blue, 42; green, 48; red, 18; yellow, 15; brown, 53; violet, 40; and black, 90.)

□ brown with violet: seeks comfort, luxury and indulgence

□ blue with gray: needs a serene environment and has a fine eye for detail

□ red with yellow: volatile and outgoing

□ yellow with brown: insecure and needs an environment allowing greater ease

□ blue with brown: needs security and peace

□ green with blue: feels compelled to conform; emotionally uninvolved

□ gray with red: irritable, feels threatened; possible cardiac problems

□ violet with yellow: emotionally withdrawn, suppresses imaginative nature

M100 BL50 **441**

Y30 M30 C50

446

Y50 C100

Y30 M100 C100 **442**

447

Y50 BL50

443

Y80 C100

448

M50 C70

444

M100

449

Y100 M100

445

Y60 M60 C50

450

Y100 M70

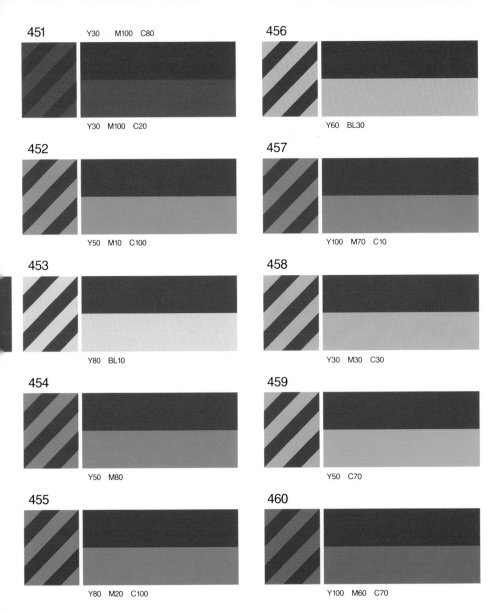

451 Y30 M100 C80

Y30 M100 C20

452

Y50 M10 C100

453

Y80 BL10

454

Y50 M80

455

Y80 M20 C100

456

Y60 BL30

457

Y100 M70 C10

458

Y30 M30 C30

459

Y50 C70

460

Y100 M60 C70

461 M90 C100 BL50
Y90 M50

466
Y10 M90 C10

462
Y30 M10 C100

467
Y30 M100 C50

463
Y50 M40 C40

468
Y60 C100

464
Y60 M100 C10

469
Y30 M60

465
Y70 M70 C70

470
Y90 M70 C40

61

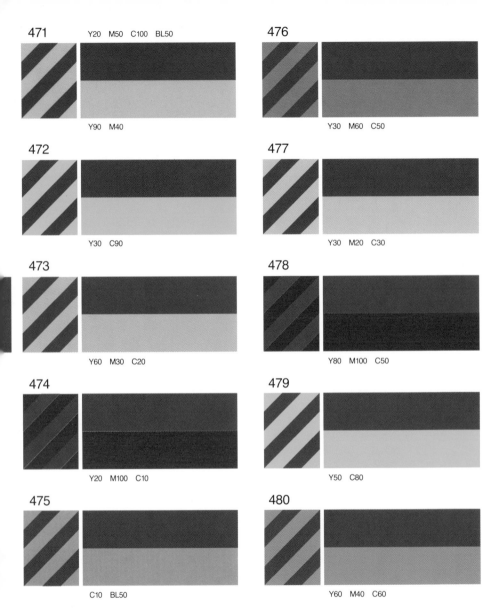

471 Y20 M50 C100 BL50

Y90 M40

476

Y30 M60 C50

472

Y30 C90

477

Y30 M20 C30

473

Y60 M30 C20

478

Y80 M100 C50

474

Y20 M100 C10

479

Y50 C80

475

C10 BL50

480

Y60 M40 C60

481 Y20 M50 C100 BL50

Y50 M60 C60

482

Y100 C100

483

Y10 M40 C50

484

Y100 M100

485

Y70 M70

486

Y90 M10 C10

487

Y90 M80 C50

488

Y90 M50 C60

489

M70 C90

490

Y10 M70 C10

63

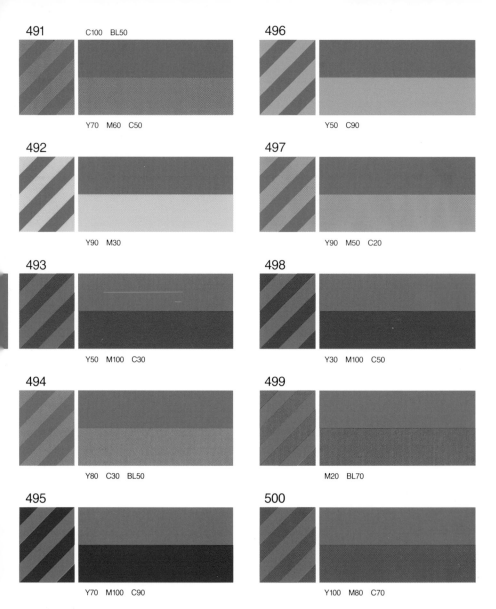

491 C100 BL50

Y70 M60 C50

492

Y90 M30

493

Y50 M100 C30

494

Y80 C30 BL50

495

Y70 M100 C90

496

Y50 C90

497

Y90 M50 C20

498

Y30 M100 C50

499

M20 BL70

500

Y100 M80 C70

C100 BL30 **501**

Y70 M70 C30

502

Y80 M90

503

Y90 M60 C70

504

C10 BL60

505

M80 C100 BL50

506

Y80 M30 C20

507

Y30 C40 BL50

508

M90 C10

509

Y100 C100

510

Y90 M80 C60 BL30

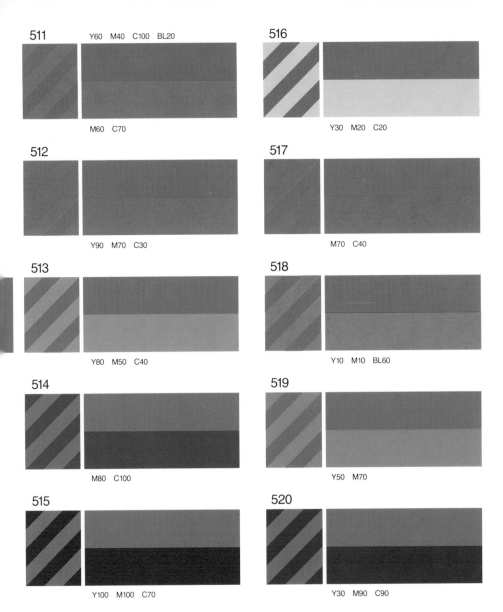

511 Y60 M40 C100 BL20

M60 C70

512

Y90 M70 C30

513

Y80 M50 C40

514

M80 C100

515

Y100 M100 C70

516

Y30 M20 C20

517

M70 C40

518

Y10 M10 BL60

519

Y50 M70

520

Y30 M90 C90

Y60 M40 C100 BL20	**521**		**526**
Y60 M30 C20		Y90 M50 C10	
	522		**527**
Y60 M80 C40		Y50 M100 C30	
	523		**528**
Y80 M80 C80		Y80 M90 C10	
	524		**529**
Y60 M50 C30		M100 C30	
	525		**530**
Y40 M40 C50		M90 C80	

67

531 Y90 C100 BL40

Y10 M70 C30

536

Y80 M70 C60

532

M70 C80

537

Y100 M40 C10

533

Y70 M70

538

M100 BL30

534

Y80 M90 C60

539

Y10 M100 C80

535

Y100 M100

540

M70 C100

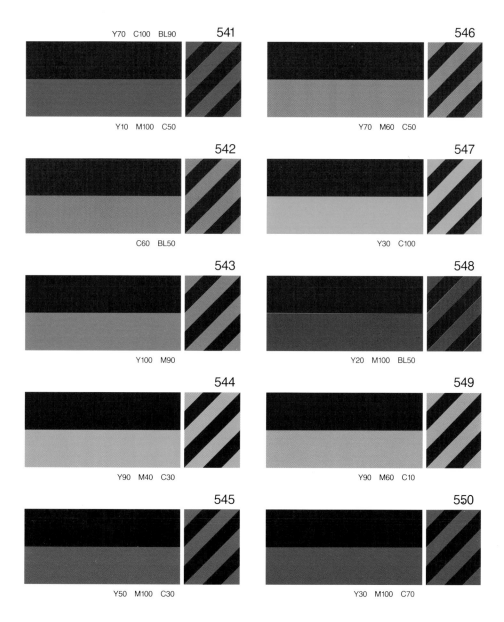

Y70　C100　BL90　**541**

Y10　M100　C50

546

Y70　M60　C50

542

C60　BL50

547

Y30　C100

543

Y100　M90

548

Y20　M100　BL50

544

Y90　M40　C30

549

Y90　M60　C10

545

Y50　M100　C30

550

Y30　M100　C70

551 Y100 M40 C80

Y40 M70 C30

552

Y20 M50 C40

553

Y50 C70

554

Y10 M30 C100

555

Y90 M80 C80

556

Y60 M80 C90

557

Y10 M90 C60

558

Y90 M40 C30

559

Y80 M90

560

Y100 M100 C60

Y90 M30 BL80 561

M90

566

Y100. M100

Y100 M70 562

567

Y40 M40 C50

Y80 M20 563

568

Y60 M100 C40

564

M50 C60

569

M90 C70

565

Y50 M10 C90

570

Y20 M70 C100 BL50

71

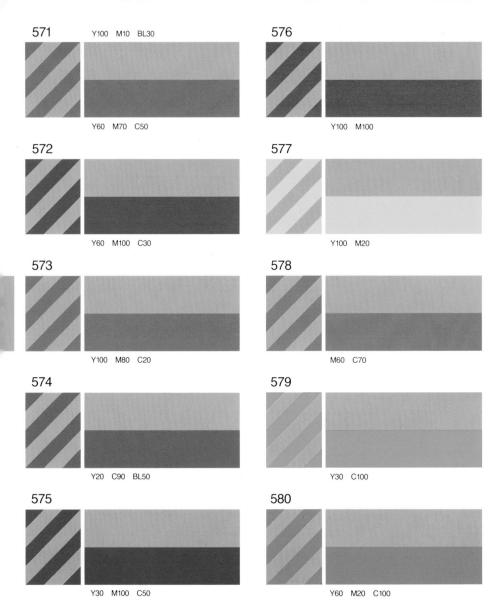

571 Y100 M10 BL30
Y60 M70 C50

576 Y100 M100

572 Y60 M100 C30

577 Y100 M20

573 Y100 M80 C20

578 M60 C70

574 Y20 C90 BL50

579 Y30 C100

575 Y30 M100 C50

580 Y60 M20 C100

72

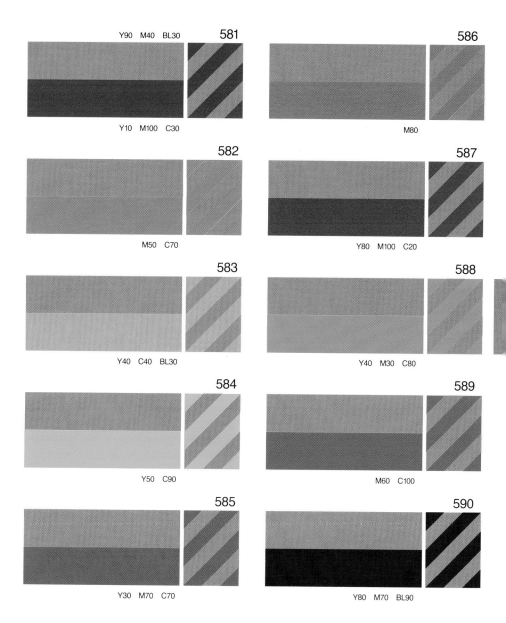

Y90　M40　BL30　**581**

Y10　M100　C30

586

M80

582

M50　C70

587

Y80　M100　C20

583

Y40　C40　BL30

588

Y40　M30　C80

584

Y50　C90

589

M60　C100

585

Y30　M70　C70

590

Y80　M70　BL90

591

Y90 M70 C40

Y30 C90

596

Y60 M30 C70

592

M100 C30

597

Y60 M40 C100 BL20

593

M10 C40 BL50

598

Y40 M80 C80

594

Y90 M100 C10

599

Y50 M70 C100

595

Y30 M100 BL60

600

Y90 BL30

Y70 M70 BL70 **601**

Y40 M70 C30 **602**

Y90 M30 C60 **603**

Y30 M30 C30 **604**

Y80 M100 C30 **605**

Y10 M30 C100

606

Y30 M90 C30 **607**

M50 C30 **608**

Y70 M20 C10 **609**

Y40 C40 BL50 **610**

Y50 M10 C100

A Little Historical Color

The first discovered aniline dye—the first dye that was organic but was synthesized rather than naturally occurring—appeared in the Victorian era, and not without some help from Queen Victoria. In 1856 the Englishman William Henry Perkin discovered the formula while attempting to synthesize quinine for treatment of malaria. He named it mauve and built a factory to produce it commercially, and in 1862 the queen promoted the endeavor by appearing at the International Exposition in a mauve dress. Unfortunately, this mauve dye produced shades that faded entirely within ten years. Nonetheless, the era of artificial dyes had begun.

The next aniline dye to appear was even more clearly a piece of history. In 1859 King Vittorio Emmanuel of Sardinia made a secret pact with Napoleon III and, hoping to unify Italy, declared war on Austria, which then controlled northern Italy. Soon after they succeeded in defeating the Austrian army in two towns west of Milan a purplish red dye was discovered. In honor of the Italians' victory and as a reminder of the Austrians' humiliating defeat, the new dye was named for one of the annexed towns: Magenta.

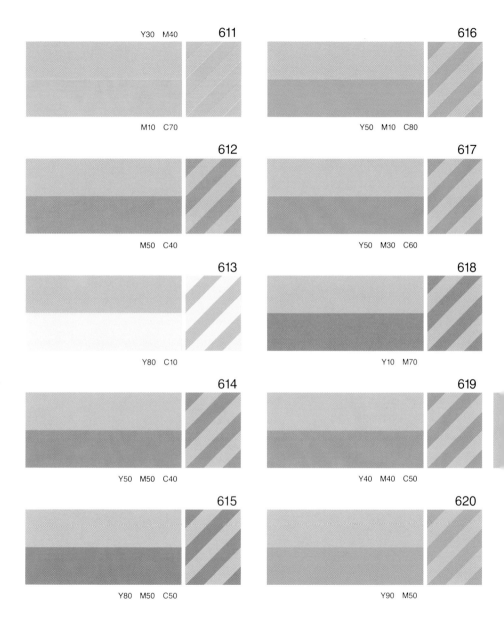

Y30 M40 **611**

M10 C70

616

Y50 M10 C80

612

M50 C40

617

Y50 M30 C60

613

Y80 C10

618

Y10 M70

614

Y50 M50 C40

619

Y40 M40 C50

615

Y80 M50 C50

620

Y90 M50

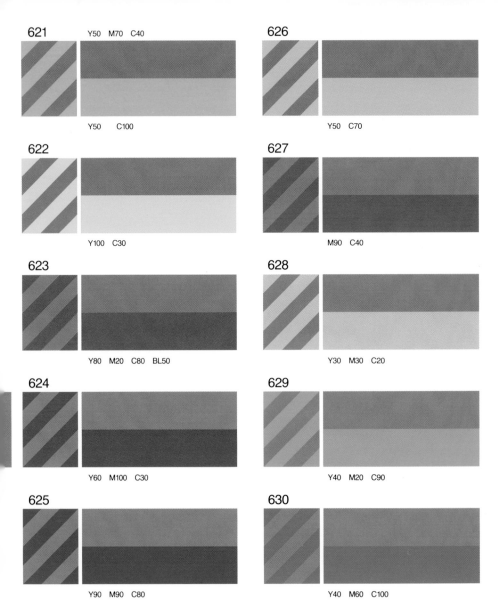

621

Y50　M70　C40

Y50　　C100

626

Y50　C70

622

Y100　C30

627

M90　C40

623

Y80　M20　C80　BL50

628

Y30　M30　C20

624

Y60　M100　C30

629

Y40　M20　C90

625

Y90　M90　C80

630

Y40　M60　C100

Y20 M40 C10 **631**

Y70 M60 C50

636

M60 C70

Y20 C70 **632**

Y20 C70

637

Y100 M100

Y60 C30 **633**

Y60 C30

638

Y70 M10 C90

Y40 C30 BL50 **634**

Y40 C30 BL50

639

Y40 M30 C100

Y30 M70 **635**

Y30 M70

640

Y70 M100 C30

641 Y30 M70 C30

Y20 C80

642

Y10 M10 BL40

643

Y80 M10 C10

644

Y50 M20 C90

645

Y80 M90 BL90

646

Y30 C80 BL50

647

Y30 M100 C40

648

Y40 M40 C20

649

Y90 M60 C90

650

Y40 M60 C80

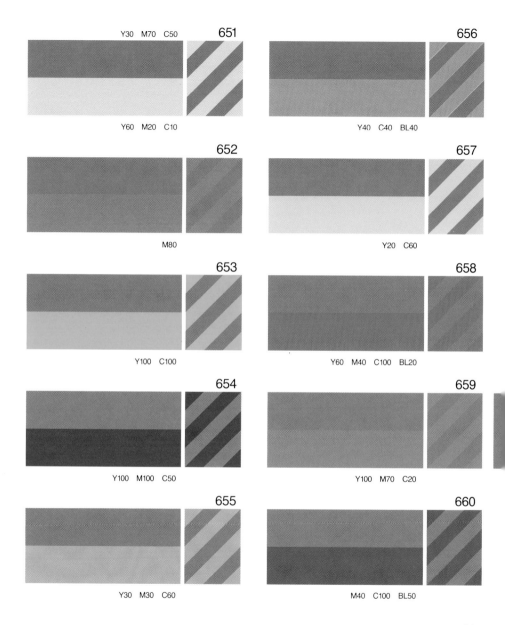

Y30 M70 C50 **651**

Y60 M20 C10

656

Y40 C40 BL40

652

M80

657

Y20 C60

653

Y100 C100

658

Y60 M40 C100 BL20

654

Y100 M100 C50

659

Y100 M70 C20

655

Y30 M30 C60

660

M40 C100 BL50

661

Y70 M100 C90

Y70 C100

662

Y10 M80 C10

663

Y50 M100 C20

664

Y30 C70 BL50

665

Y80 M40 C30

666

Y40 M30 C40

667

Y60 M70 C60

668

Y10 M100 BL50

669

Y50 C80

670

Y40 C90

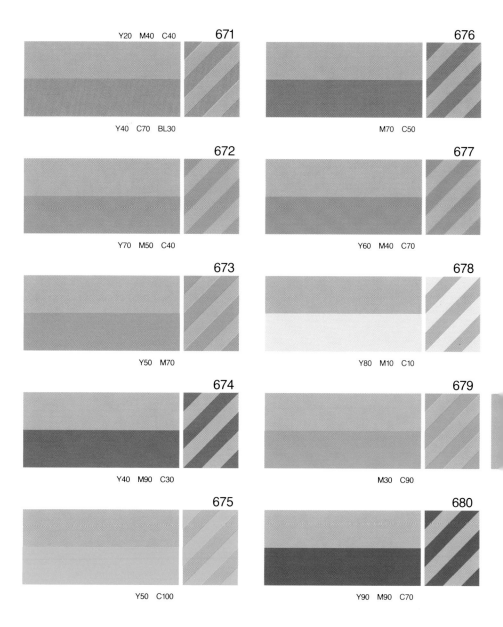

Y20 M40 C40 **671**

Y40 C70 BL30

672

Y70 M50 C40

673

Y50 M70

674

Y40 M90 C30

675

Y50 C100

676

M70 C50

677

Y60 M40 C70

678

Y80 M10 C10

679

M30 C90

680

Y90 M90 C70

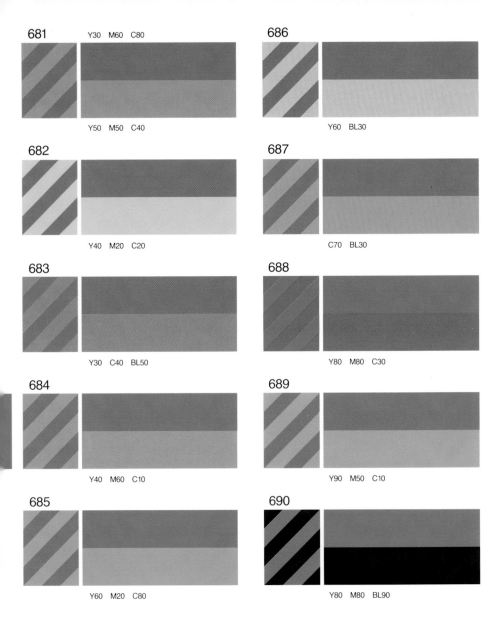

681　Y30　M60　C80

Y50　M50　C40

682

Y40　M20　C20

683

Y30　C40　BL50

684

Y40　M60　C10

685

Y60　M20　C80

686

Y60　BL30

687

C70　BL30

688

Y80　M80　C30

689

Y90　M50　C10

690

Y80　M80　BL90

691

Y30　M50　C60

696

Y30　M70

692

Y80　M40　C10

697

Y80　M90

693

Y10　M90　C60

698

Y90　M100　C80

694

Y60　M40　C100

699

Y30　M90　BL40

695

Y90　M60　C80

700

Y40　M70　C100

Y70　C100　BL90

701 Y30 M50 C80

Y70 M10

706

Y50 M50

702

Y50 C70

707

Y10 M70

703

Y50 M70

708

Y30 C90

704

Y50 BL30

709

Y80 M70 C40

705

Y70 M100 C70

710

Y50 M100 C50

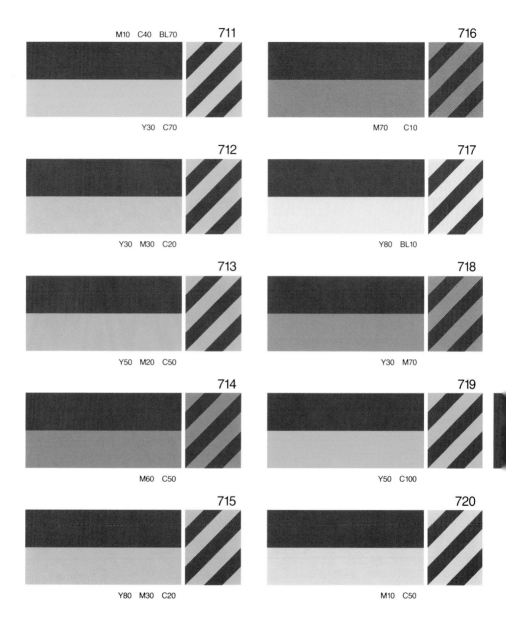

M10　C40　BL70　**711**

Y30　C70

716

M70　C10

Y30　M30　C20　**712**

717

Y80　BL10

Y50　M20　C50　**713**

718

Y30　M70

M60　C50　**714**

719

Y50　C100

Y80　M30　C20　**715**

720

M10　C50

721 Y40 M70 C100

M50 C70

726

Y60 M80 C40

722

Y30 C70

727

Y80 M60 C50

723

Y70 M40 C10

728

Y40 M40 C40 BL10

724

Y80 M100 C30

729

Y30 M70

725

Y40 C50 BL50

730

Y60 C80

731 C30 BL40
Y60 M100 C70

736
Y50 M70

732
Y50 M10 C100

737
Y70 M30 C70 BL10

733
Y90 M90 C50

738
M70 C70

734
Y50 M100 C40

739
Y90 M30

735
M60 C100 BL50

740
Y60 M40 C90 BL10

The Lure of Hue

In some uses of color in nature, seemingly no purpose is served but the pleasure of the eye. Witness the electric hues of tropical fish or riotously colorful displays of jungle-dwelling birds and monkeys. But though these animals' arrays of color have little intrinsic meaning for human observers, they carry precisely interpreted meanings for the species that carry them. For fish, the markings are means of exact identification where similarity of species would otherwise engender fatal confusion. For the male tropical bower bird, colors signal potential mates of his availability. Of course, this is true of many birds, but the bower bird goes a step further by assembling a collection of found items in yellow-green and a shade of blue akin to that of his feathers to heighten the effect of his own appealing color scheme. He even acquires blue berries, mashes them, and paints the walls of his bower blue with them.

Monkeys, which have little to fear in their tree-canopy habitat, signal each other flagrantly in vivid hues—red faces so bright they almost seem to glow from within, combined white, blue, orange and black in a single visage, and startlingly blue genitals signal differing species, sexes and intentions.

As might be expected, species that particularly rely on color in their appearance are often facile in other uses of color. Monkeys have acute color vision, which helps not only in identification of other monkeys but in perceiving the ripeness of fruit and soundness of forest greenery. Squids and cuttlefish enlarge or contract percentages of three layers of pigment cells, each layer a different color, to blend with their backgrounds. They manage this with their central nervous systems, but how they translate visual perceptions into the enlargement and contraction of cells so as to produce specific pigment changes is unknown. The technique is complex, producing either rippling waves of color that attract prey or camouflage that misleads predators, and it's fast; squids and cuttlefish can change color in as little as two-thirds of a second. Most bony fish, which rely heavily on color for identification, have excellent color vision. Most sharks, which do not see the color spectrum, are themselves somberly hued, and even unoriginally patterned in the simplest of mottlings. Color not being a tool sharks use vitally, they employ it in hardly any way at all.

Y30　M20　C80 **741**

Y40　M50　C10

Y20　M70　C20 **742**

Y40　M40　C40　BL10 **743**

Y80　M30　C20 **744**

Y50　M80　C60 **745**

746 Y90　M70　C40

747 Y60　M20　C40　BL50

748 Y90　M80　C80

749 Y30　M50　C70

750 Y30　C50　BL80

91

751 Y40 M50 C100
Y90 M70 C30

752 Y30 M100

753 Y60 C30 BL50

754 Y100 M100

755 M100 C50

756 Y30 M50

757 Y80 M60 C50

758 Y10 M10 C30 BL30

759 Y50 C70

760 Y30 M100 C60 BL30

Y40 M50 C100 **761**

Y90 M30 C10

766

Y30 M30 C10

Y30 C100 **762**

767

M50 C70

763

Y60 M80 C40

768

Y20 M40 C40

764

M90

769

Y90 M50 C50

765

Y60 M100 C40

770

Y80 M70

771
Y70 M70 C100
Y50 M100 C40

776
Y30 M100 C70

772
M40 C90

777
Y80 M40 C10 BL30

773
Y80 M40 C10

778
M70 C50

774
Y80 M70 C20

779
Y50 C100

775
Y100 C100

780
Y40 M70 C30

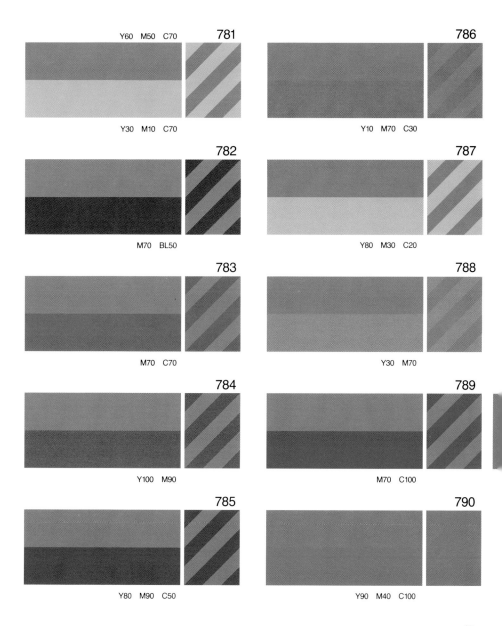

Y60 M50 C70 **781**

Y30 M10 C70

782

M70 BL50

783

M70 C70

784

Y100 M90

785

Y80 M90 C50

786

Y10 M70 C30

787

Y80 M30 C20

788

Y30 M70

789

M70 C100

790

Y90 M40 C100

95

791 Y60 M50 C90

M30 C70

792

Y70 M90

793

Y100 M70

794

Y30 M90 C20

795

M40 C40 BL50

796

Y50 M50 C50

797

Y50 C90

798

Y70 M70 C20

799

Y20 M70 C70

800

Y40 M70 C30

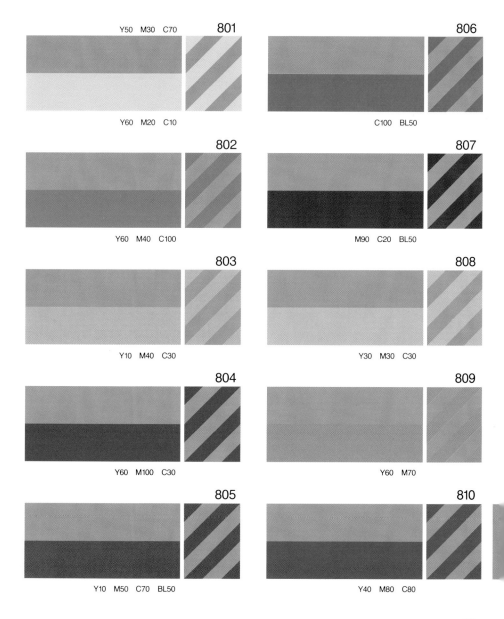

Y50 M30 C70 **801**

Y60 M20 C10

Y60 M40 C100 **802**

Y10 M40 C30 **803**

Y60 M100 C30 **804**

Y10 M50 C70 BL50 **805**

806

C100 BL50

807

M90 C20 BL50

808

Y30 M30 C30

809

Y60 M70

810

Y40 M80 C80

811 Y50 C30 BL50

M30 C70

816

M50 C50

812

Y90 M10

817

Y20 M40 BL20

813

M100 C30

818

Y90 M90

814

M50 C100

819

Y100 M70

815

Y20 M80 C60 BL50

820

Y70 C90

Y70 M30 C50 **821**

Y30 M100

826

C50 BL50

Y30 M30 C100 **822**

827

Y80 M100 C10

823

Y10 M90 C70

828

Y80 M30 C10

824

M100 BL50

829

Y90 M90 C60 BL10

825

Y50 M50 C50 BL50

830

M70 C100 BL50

831 Y80 M30 C60 BL50
Y100 M100 C10

832
Y100 M70

833
Y60 M70 C40

834
M100 C80

835
M90 C100

836
M100 BL40

837
Y30 M80

838
Y60 BL10

839
Y80 M50 C30

840
Y90 M90 C80

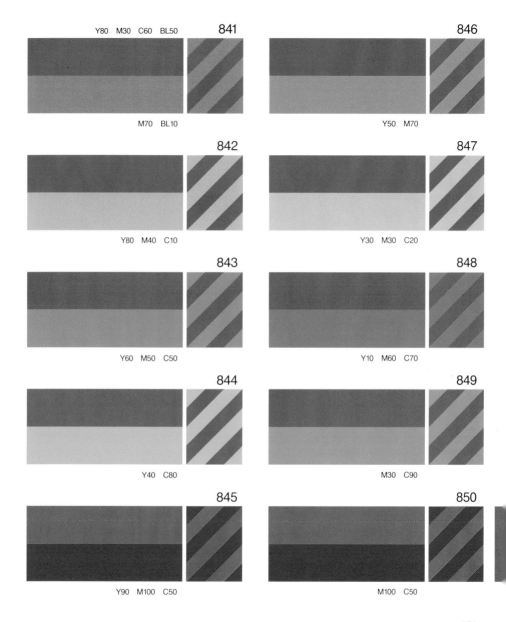

841
Y80 M30 C60 BL50

846

842
M70 BL10

Y50 M70

847
Y80 M40 C10

Y30 M30 C20

843

848
Y60 M50 C50

Y10 M60 C70

844

849
Y40 C80

M30 C90

845

850
Y90 M100 C50

M100 C50

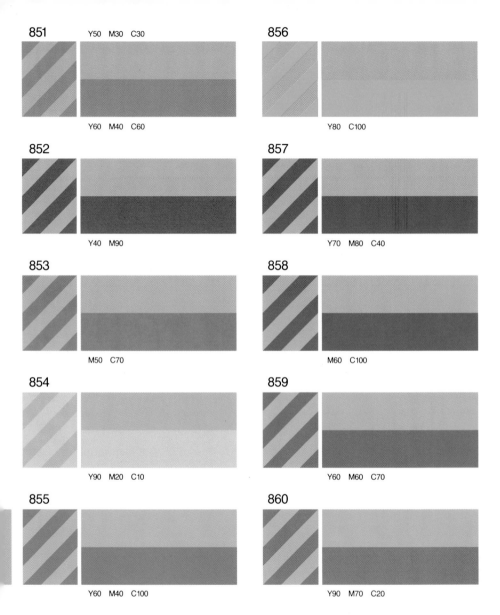

851 Y50 M30 C30
Y60 M40 C60

856 Y80 C100

852
Y40 M90

857 Y70 M80 C40

853
M50 C70

858 M60 C100

854
Y90 M20 C10

859 Y60 M60 C70

855
Y60 M40 C100

860 Y90 M70 C20

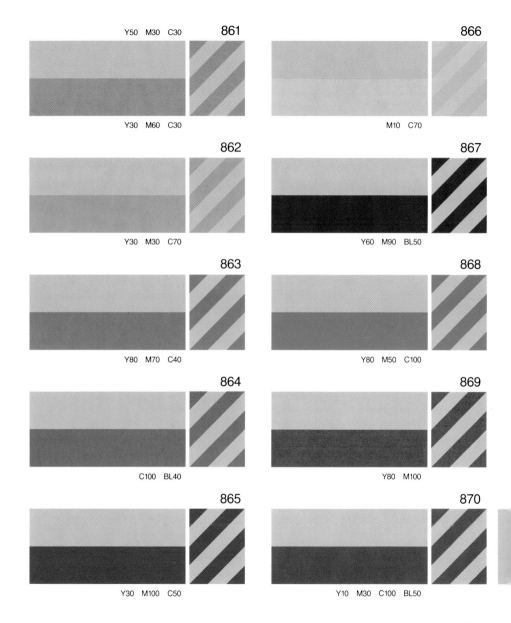

Y50 M30 C30 **861**

Y30 M60 C30

866

M10 C70

Y30 M30 C70 **862**

867

Y60 M90 BL50

Y80 M70 C40 **863**

868

Y80 M50 C100

C100 BL40 **864**

869

Y80 M100

Y30 M100 C50 **865**

870

Y10 M30 C100 BL50

Noxious Advertisement

Camouflaging colors protect many species of animals, but for others the effective defense is just the opposite. Aposematic animals advertise aversive qualities with bold displays of colors, which are usually vivid and patterned to be distinctly perceivable. A Bornean stinkbug is solidly bright pink. The advantage of his technique is in avoidance of warfare, and indeed any predator that once attacks a bug with a secretion as noxious as the stinkbug's is not likely to try it again. Similarly, a Malaysian worm stands out from its typically green background in strong orange and black stripes. This warns off attackers, thereby avoiding loss of any of the worm's flesh before an attacker can react to its nauseating taste. The tiger moth signals the toxicity of its bloodstream with a special red display that appears only when the moth is threatened. Obviously, many species benefit from learning well that bold colors mean trouble. A few species seem to have learned it to particular advantage. For example, the Arizona king snake has stripes in much the same colors and sizes as the poisonous coral snake's stripes, but the king, a nonpoisonous snake, is bluffing.

Evolution of Color in Flowers

Although the first plants appeared on this earth five hundred million years ago, another fifty million years passed before they began producing flowers, and even then blooms were not boldly prominent. About 100 million years ago, long before human beings developed, flowers as they're known today began to appear in various colors. Insects can be credited for determining which colors flourished, since insects are sensitive to the shorter wavelengths of color and actually only see four sets of wavelengths: orange-green, green-blue, blue-violet and ultraviolet. Flower color has evolved due to its ability or inability to attract insects for pollination; few red flowers have survived in the natural world, but many blue and purple flowers bloom in the spring and summer, when insects are most active.

Y90 M70 C70 **871**

Y30 C70

876

Y100 M90

Y20 M10 C40 BL30 **872**

877

M90

Y80 M100 C30 **873**

878

Y60 C100

M50 C70 **874**

879

Y90 M30

Y100 C100 **875**

880

C100 BL50

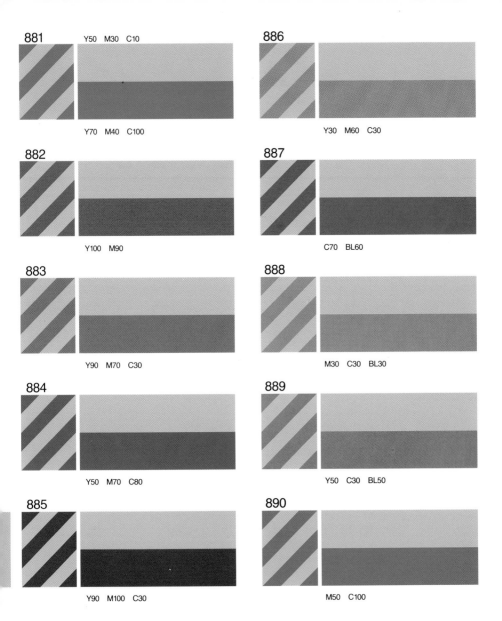

881 Y50 M30 C10
Y70 M40 C100

882
Y100 M90

883
Y90 M70 C30

884
Y50 M70 C80

885
Y90 M100 C30

886
Y30 M60 C30

887
C70 BL60

888
M30 C30 BL30

889
Y50 C30 BL50

890
M50 C100

891
Y80 M50 C40
M100 C50

896
Y100 C30

892
Y90 M50

897
Y80 C100

893
Y100 M100

898
Y30 M100

894
M10 C100

899
Y90 M30 C50 BL50

895
Y70 C100 BL90

900
Y60 M50 C80 BL30

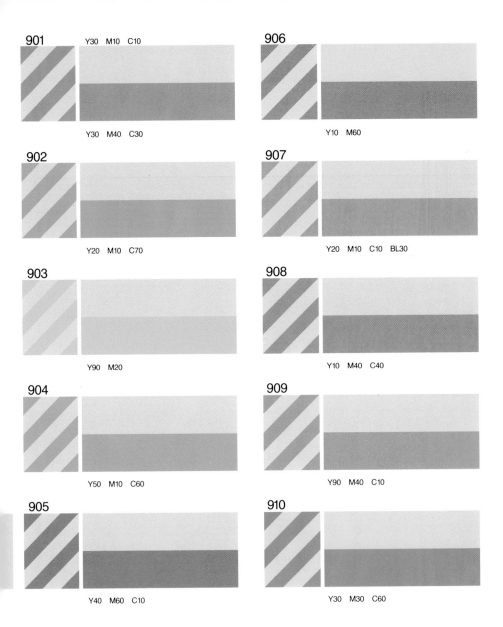

901 Y30 M10 C10

Y30 M40 C30

906

Y10 M60

902

Y20 M10 C70

907

Y20 M10 C10 BL30

903

Y90 M20

908

Y10 M40 C40

904

Y50 M10 C60

909

Y90 M40 C10

905

Y40 M60 C10

910

Y30 M30 C60

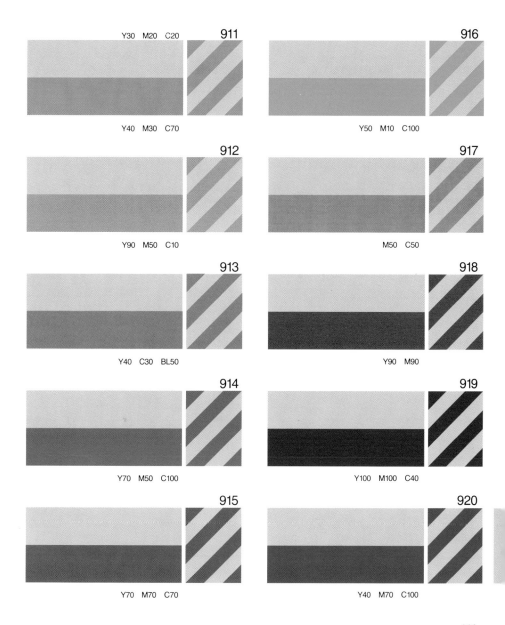

Y30 M20 C20 **911**

Y40 M30 C70

Y50 M10 C100 **916**

912

Y90 M50 C10

917

M50 C50

913

Y40 C30 BL50

918

Y90 M90

914

Y70 M50 C100

919

Y100 M100 C40

915

Y70 M70 C70

920

Y40 M70 C100

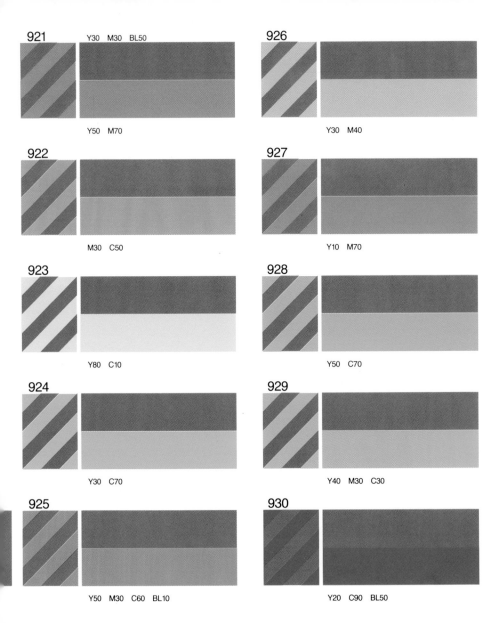

921 Y30 M30 BL50

Y50 M70

926

Y30 M40

922

M30 C50

927

Y10 M70

923

Y80 C10

928

Y50 C70

924

Y30 C70

929

Y40 M30 C30

925

Y50 M30 C60 BL10

930

Y20 C90 BL50

110

Y30 M30 BL50 **931**

Y100 BL40

936

Y100 M90

932

M70 C50

937

Y80 M40 C10

933

C100 BL30

938

Y80 C100

934

Y80 M100 C50

939

M100 C50

935

Y60 M40 C100 BL20

940

M90 C100 BL50

941 Y60 M60 C40

Y20 M30 C80

942

Y30 M70

943

Y50 C80

944

Y20 M30 C50 BL30

945

M90 C20 BL50

946

M70 BL40

947

Y40 C30 BL50

948

Y30 M70 C80

949

Y90 M50

950

Y50 M70 C100

Y50 M50 BL80 **951**

Y50 M70

M30 C80 **952**

Y10 M70 C10 **953**

Y10 M10 C40 BL30 **954**

Y20 C90 BL50 **955**

Y40 C70 **956**

Y70 BL30 **957**

Y70 M10 C100 **958**

M100 C40 **959**

Y50 M20 C50 **960**

Whispering White, B-minor Black

A is black, E is white, I is red, U is green, O is blue, wrote the poet Rimbaud. In the sixteenth century, an English poet described auditory tones of color: for him, pearly white conveyed faint whispers; blue, creaks; pale blue, an oboe sound; green, woodwinds; yellow, the sweet and soft wind instruments; and orange, all brass instruments. These are the felicitous associations of synesthesia, the not-uncommon phenomenon of sensory impressions in one modality evoking impressions in another. Some such associations are elaborately specific. Goethe attributed dark blue to the cello, ultramarine to violins, rose to the oboe, yellow to clarinets, violet to horns, red to trumpets and light blue to the flute called the flageolet. Kandinsky noted that as the intensity of yellow increased it "sounds" like a flute; and dark blue, he said, ranges from cello to contrabass. Franz Liszt once described a composition he was writing as needing a little pink here, there sounding too black; overall, he wanted it sky blue. Beethoven called the key of B-minor the black minor, and Schubert termed E-minor a young girl with rose nipples visible through a white uniform. Like photographic (eidetic) memory, synesthesia seems stronger in youths; if the parallel continues, perhaps synesthesia, too, can be cultivated.

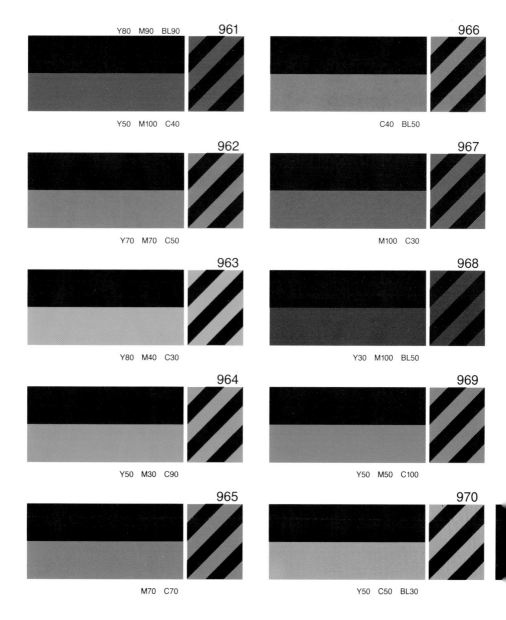

Y80 M90 BL90
961

Y50 M100 C40

C40 BL50
966

962

Y70 M70 C50

M100 C30
967

963

Y80 M40 C30

Y30 M100 BL50
968

964

Y50 M30 C90

Y50 M50 C100
969

965

M70 C70

Y50 C50 BL30
970

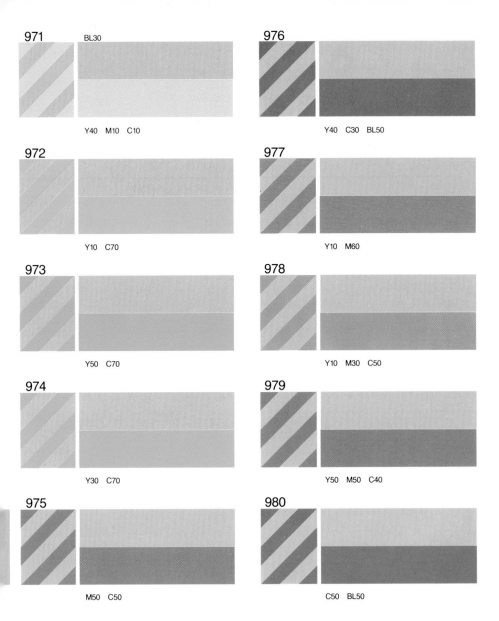

971 BL30

Y40 M10 C10

972

Y10 C70

973

Y50 C70

974

Y30 C70

975

M50 C50

976

Y40 C30 BL50

977

Y10 M60

978

Y10 M30 C50

979

Y50 M50 C40

980

C50 BL50

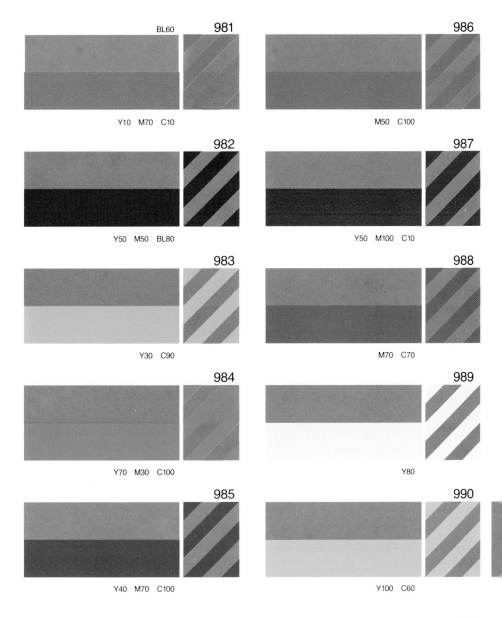

981 BL60

Y10 M70 C10

982

Y50 M50 BL80

983

Y30 C90

984

Y70 M30 C100

985

Y40 M70 C100

986

M50 C100

987

Y50 M100 C10

988

M70 C70

989

Y80

990

Y100 C60

991 BL80
Y80 M70

996
Y90 M10

992
M50 C70

997
Y50 M10 C100

993
Y50 M90

998
Y10 M70 C100

994
Y30 M70

999
M90

995
Y90 M50

1000
Y70 C100 BL90

1001
BL80
Y60 M50 C20

1006
M100 BL50

1002
Y30 C70

1007
Y40 M10 C50

1003
Y70 M10 C100

1008
Y40 M40 C100

1004
M70 C30

1009
M10 C70

1005
Y70 M50 C40

1010
Y90 M40 C30

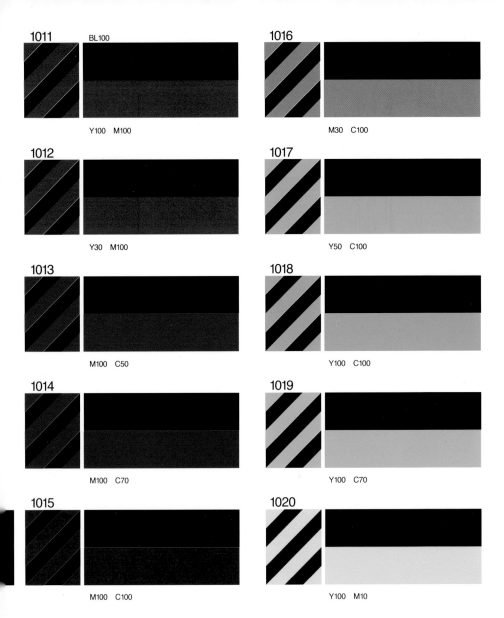

1011 BL100

Y100 M100

1012

Y30 M100

1013

M100 C50

1014

M100 C70

1015

M100 C100

1016

M30 C100

1017

Y50 C100

1018

Y100 C100

1019

Y100 C70

1020

Y100 M10

120

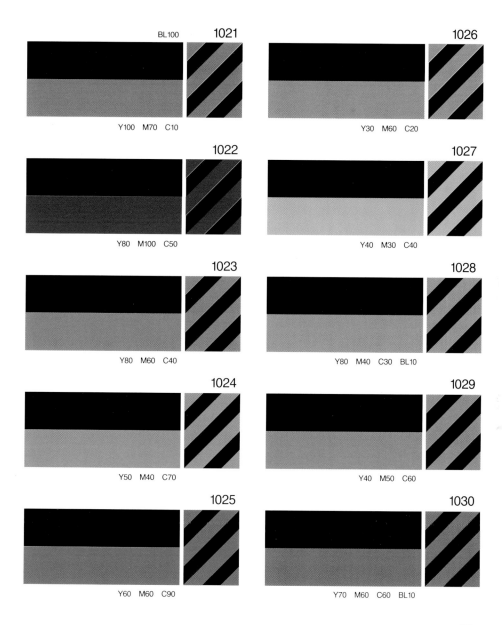

1021 BL100
Y100 M70 C10

1026
Y30 M60 C20

1022
Y80 M100 C50

1027
Y40 M30 C40

1023
Y80 M60 C40

1028
Y80 M40 C30 BL10

1024
Y50 M40 C70

1029
Y40 M50 C60

1025
Y60 M60 C90

1030
Y70 M60 C60 BL10

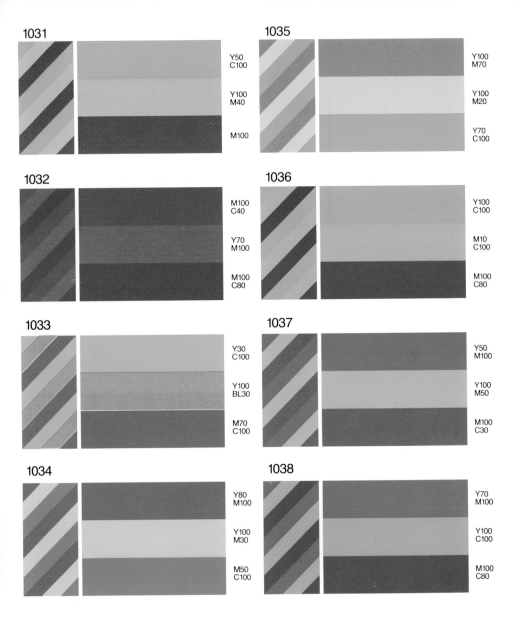

1031

Y50
C100

Y100
M40

M100

1035

Y100
M70

Y100
M20

Y70
C100

1032

M100
C40

Y70
M100

M100
C80

1036

Y100
C100

M10
C100

M100
C80

1033

Y30
C100

Y100
BL30

M70
C100

1037

Y50
M100

Y100
M50

M100
C30

1034

Y80
M100

Y100
M30

M50
C100

1038

Y70
M100

Y100
C100

M100
C80

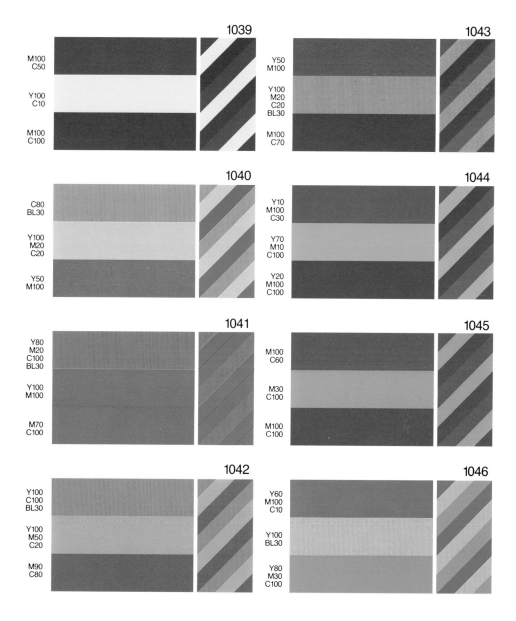

1039

M100
C50

Y100
C10

M100
C100

1040

C80
BL30

Y100
M20
C20

Y50
M100

1041

Y80
M20
C100
BL30

Y100
M100

M70
C100

1042

Y100
C100
BL30

Y100
M50
C20

M90
C80

1043

Y50
M100

Y100
M20
C20
BL30

M100
C70

1044

Y10
M100
C30

Y70
M10
C100

Y20
M100
C100

1045

M100
C60

M30
C100

M100
C100

1046

Y60
M100
C10

Y100
BL30

Y80
M30
C100

The Blue of Spring, Battle and Leonardo

The use of indigo as a dye is so old and so widespread that cultural traditions have grown up around its use everywhere, many of them calling upon blue's preponderance in the environment in water and sky. In China blue was associated with the east, and in Tibet, with the south. In Japan blue connoted spring and also victory in battle. Because blue was thought to keep poisonous snakes at bay in Japan, it was often used for work and traveling clothes. The Egyptians, who used indigo as early as 4500 B.C., colored the sheets used to wrap mummies blue.

The Romans identified some endeavors of the citizenry by garment color: black for theologians, green for doctors and white for fortune tellers; and blue, both in ancient Rome and in the system of academic robe colors adopted by American universities in 1893, has identified philosophers. With perhaps some degree of parallel in qualities thus associated with blue, Christian art typically has used it to signify pacific virtue; an unaggressive, thoughtful stance. Theorists have speculated that colors convey tension when shaded toward another color. Accordingly, blue added to, say, green or red may be more expressive and evocative than blue in its own pure, relatively neutral state.

Colors That Fly

A prime cultural use of color is in flags, and here, as in the strongest signals in nature, hues almost always are vibrant and bold. The flag of Islam—green plus red, white and black—assertively combines associations of courage and blood (red), tolerance (white) and victory (for Islamics, black). The use of green with black signifies pan-Arabism, and all the flags of the Arab nations employ this four-color scheme. In Africa, the color schemes chosen by nations that achieved independence in the 1950s and 1960s are predominantly green, red and yellow: green for fertile lands, red for blood lost in revolution and yellow for the sun and natural resources.

When the French tricolor first appeared at the time of the French Revolution in 1789, red and blue were colors of Paris and white represented the Bourbon line. The colors can be traced back further, however, to the blue coat of St. Martin, the white flag of Jeanne d'Arc, and the red flag of St. Daniel and the French kings. During the revolutions of 1848 and 1871, an all-red flag was used except for only a few days in 1848 when a blue, red and white flag appeared.

Britain's flag combines the crosses of the guardians of three countries; red on a white field for St. George of England, White on blue for St. Andrew of Scotland, and red on white for St. Patrick of Ireland.

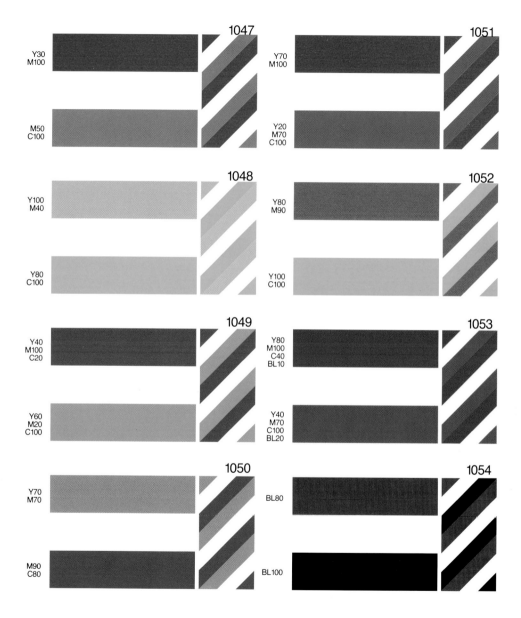

1047
Y30 M100
M50 C100

1051
Y70 M100
Y20 M70 C100

1048
Y100 M40
Y80 C100

1052
Y80 M90
Y100 C100

1049
Y40 M100 C20
Y60 M20 C100

1053
Y80 M100 C40 BL10
Y40 M70 C100 BL20

1050
Y70 M70
M90 C80

1054
BL80
BL100

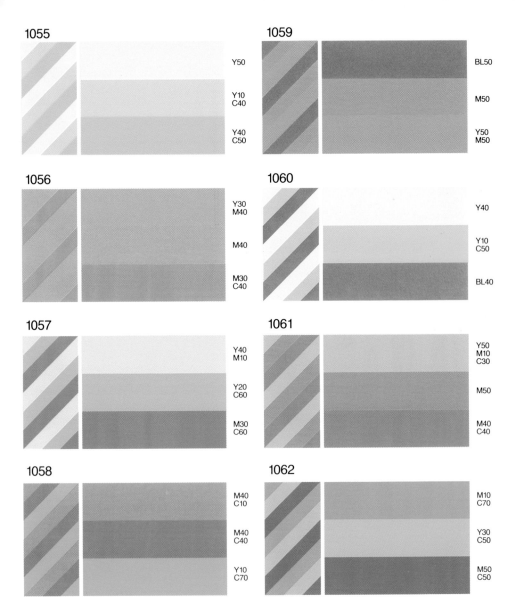

1055

Y50

Y10
C40

Y40
C50

1059

BL50

M50

Y50
M50

1056

Y30
M40

M40

M30
C40

1060

Y40

Y10
C50

BL40

1057

Y40
M10

Y20
C60

M30
C60

1061

Y50
M10
C30

M50

M40
C40

1058

M40
C10

M40
C40

Y10
C70

1062

M10
C70

Y30
C50

M50
C50

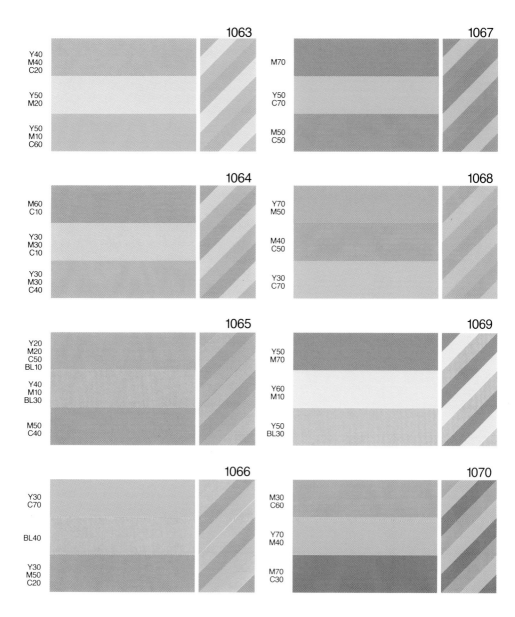

1063

Y40
M40
C20

Y50
M20

Y50
M10
C60

1064

M60
C10

Y30
M30
C10

Y30
M30
C40

1065

Y20
M20
C50
BL10

Y40
M10
BL30

M50
C40

1066

Y30
C70

BL40

Y30
M50
C20

1067

M70

Y50
C70

M50
C50

1068

Y70
M50

M40
C50

Y30
C70

1069

Y50
M70

Y60
M10

Y50
BL30

1070

M30
C60

Y70
M40

M70
C30

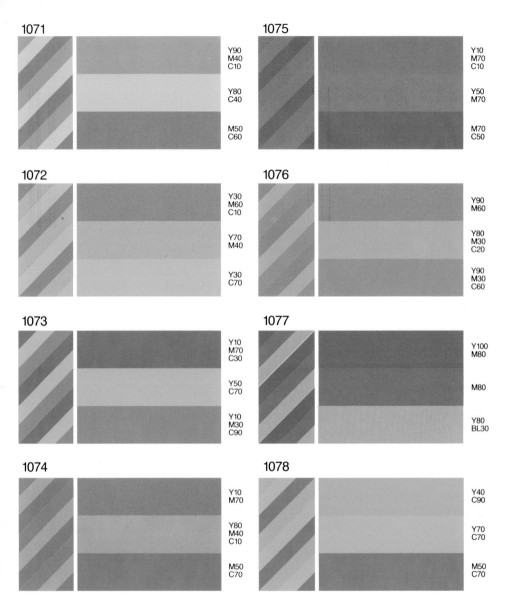

1071

Y90
M40
C10

Y80
C40

M50
C60

1075

Y10
M70
C10

Y50
M70

M70
C50

1072

Y30
M60
C10

Y70
M40

Y30
C70

1076

Y90
M60

Y80
M30
C20

Y90
M30
C60

1073

Y10
M70
C30

Y50
C70

Y10
M30
C90

1077

Y100
M80

M80

Y80
BL30

1074

Y10
M70

Y80
M40
C10

M50
C70

1078

Y40
C90

Y70
C70

M50
C70

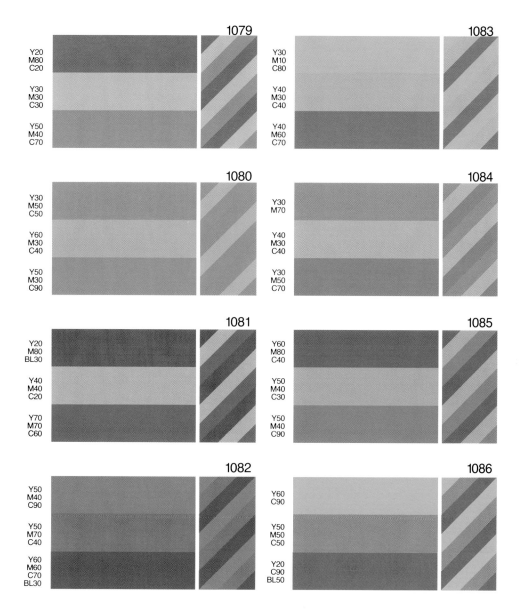

1079

Y20
M80
C20

Y30
M30
C30

Y50
M40
C70

1080

Y30
M50
C50

Y60
M30
C40

Y50
M30
C90

1081

Y20
M80
BL30

Y40
M40
C20

Y70
M70
C60

1082

Y50
M40
C90

Y50
M70
C40

Y60
M60
C70
BL30

1083

Y30
M10
C80

Y40
M30
C40

Y40
M60
C70

1084

Y30
M70

Y40
M30
C40

Y30
M50
C70

1085

Y60
M80
C40

Y50
M40
C30

Y50
M40
C90

1086

Y60
C90

Y50
M50
C50

Y20
C90
BL50

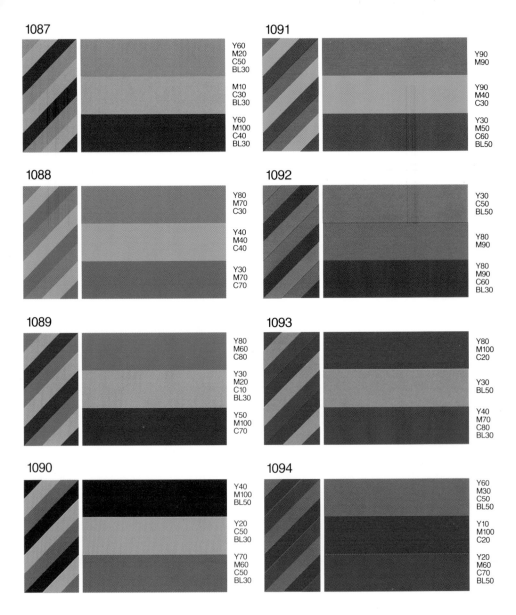

1087

Y60
M20
C50
BL30

M10
C30
BL30

Y60
M100
C40
BL30

1088

Y80
M70
C30

Y40
M40
C40

Y30
M70
C70

1089

Y80
M60
C80

Y30
M20
C10
BL30

Y50
M100
C70

1090

Y40
M100
BL50

Y20
C50
BL30

Y70
M60
C50
BL30

1091

Y90
M90

Y90
M40
C30

Y30
M50
C60
BL50

1092

Y30
C50
BL50

Y80
M90

Y80
M90
C60
BL30

1093

Y80
M100
C20

Y30
BL50

Y40
M70
C80
BL30

1094

Y60
M30
C50
BL50

Y10
M100
C20

Y20
M60
C70
BL50

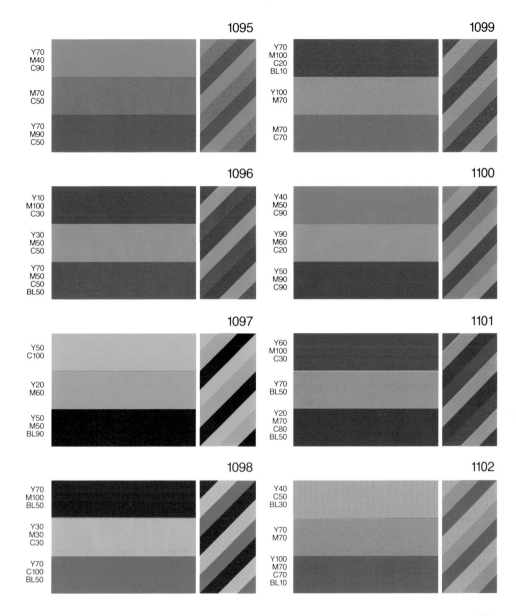

1095

Y70
M40
C90

M70
C50

Y70
M90
C50

1099

Y70
M100
C20
BL10

Y100
M70

M70
C70

1096

Y10
M100
C30

Y30
M50
C50

Y70
M50
C50
BL50

1100

Y40
M50
C90

Y90
M60
C20

Y50
M90
C90

1097

Y50
C100

Y20
M60

Y50
M50
BL90

1101

Y60
M100
C30

Y70
BL50

Y20
M70
C80
BL50

1098

Y70
M100
BL50

Y30
M30
C30

Y70
C100
BL50

1102

Y40
C50
BL30

Y70
M70

Y100
M70
C70
BL10

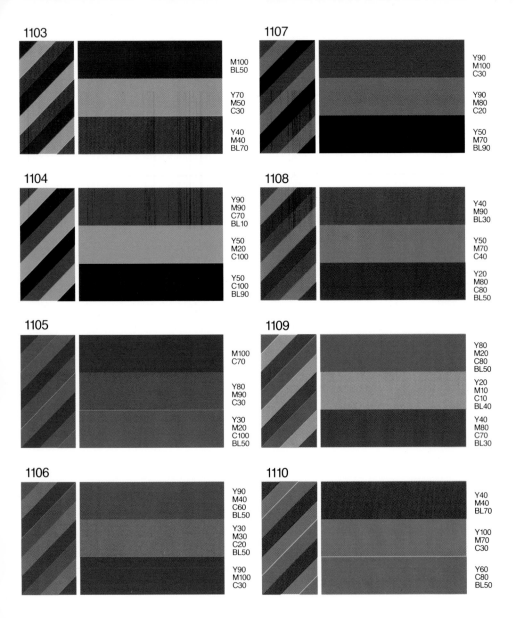

1103

M100
BL50

Y70
M50
C30

Y40
M40
BL70

1104

Y90
M90
C70
BL10

Y50
M20
C100

Y50
C100
BL90

1105

M100
C70

Y80
M90
C30

Y30
M20
C100
BL50

1106

Y90
M40
C60
BL50

Y30
M30
C20
BL50

Y90
M100
C30

1107

Y90
M100
C30

Y90
M80
C20

Y50
M70
BL90

1108

Y40
M90
BL30

Y50
M70
C40

Y20
M80
C80
BL50

1109

Y80
M20
C80
BL50

Y20
M10
C10
BL40

Y40
M80
C70
BL30

1110

Y40
M40
BL70

Y100
M70
C30

Y60
C80
BL50

1111

Y30
M100
BL50

Y60
M40
C20
BL30

Y20
M50
C50
BL30

1112

Y100
M70
C50
BL30

Y70
M20
C100

Y60
M100
C90

1113

M70
BL70

Y90
M100
C30

Y50
M50
BL90

1114

Y60
M100
C70
BL10

Y100
M90
C50
BL10

Y80
C100
BL90

1115

Y70
M100
C90

Y30
C40
BL50

Y60
M50
C100

1116

Y80
M40
C90

Y20
M100
BL40

M60
C50
BL70

1117

M100
BL50

Y100
M60
C40

Y50
M100
C100

1118

Y10
M70
C100
BL50

Y70
M100
BL50

Y60
M50
C100

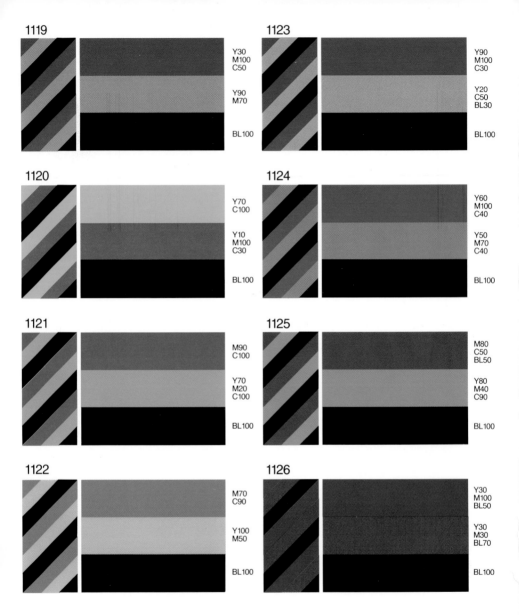

1119

Y30
M100
C50

Y90
M70

BL100

1123

Y90
M100
C30

Y20
C50
BL30

BL100

1120

Y70
C100

Y10
M100
C30

BL100

1124

Y60
M100
C40

Y50
M70
C40

BL100

1121

M90
C100

Y70
M20
C100

BL100

1125

M80
C50
BL50

Y80
M40
C90

BL100

1122

M70
C90

Y100
M50

BL100

1126

Y30
M100
BL50

Y30
M30
BL70

BL100

134

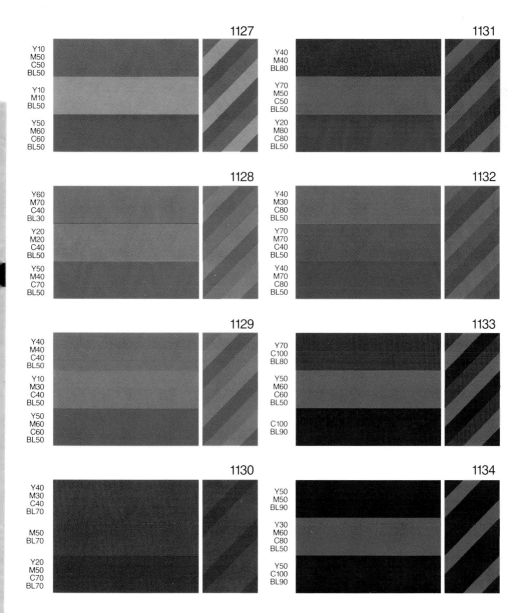

1127

Y10 M50 C50 BL50

Y10 M10 BL50

Y50 M60 C60 BL50

1128

Y60 M70 C40 BL30

Y20 M20 C40 BL50

Y50 M40 C70 BL50

1129

Y40 M40 C40 BL50

Y10 M30 C40 BL50

Y50 M60 C60 BL50

1130

Y40 M30 C40 BL70

M50 BL70

Y20 M50 C70 BL70

1131

Y40 M40 BL80

Y70 M50 C50 BL50

Y20 M80 C80 BL50

1132

Y40 M30 C80 BL50

Y70 M70 C40 BL50

Y40 M70 C80 BL50

1133

Y70 C100 BL80

Y50 M60 C60 BL50

C100 BL90

1134

Y50 M50 BL90

Y30 M60 C80 BL50

Y50 C100 BL90